IMAGES
of America

WORLD WAR II IN
ATLANTA

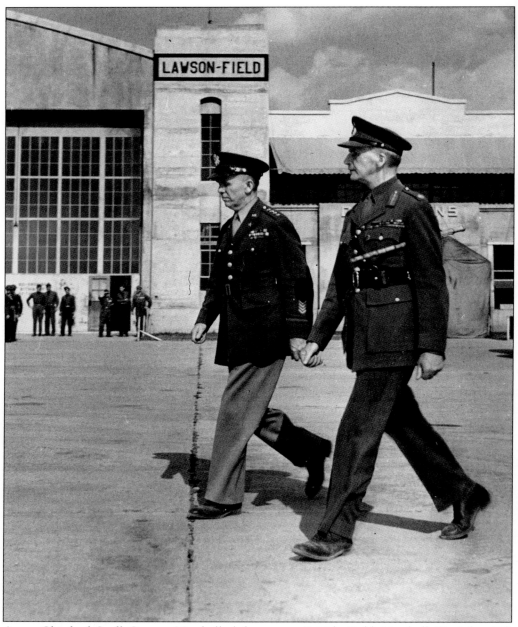

Army Chief of Staff George Marshall, left, escorts British Field Marshall Sir John Dill across the tarmac at Lawson Field for a surprise inspection of the troops at Fort Benning in Columbus, Georgia.

IMAGES
of America

WORLD WAR II IN
ATLANTA

Paul Crater

ARCADIA

Published by Arcadia Publishing
an imprint of Tempus Publishing Inc.
Charleston SC, Chicago, Portsmouth NH, San Francisco

Printed in Great Britain

Library of Congress Catalog Card Number: 2003109545

For all general information contact Arcadia Publishing at:
Telephone 843-853-2070
Fax 843-853-0044
E-mail sales@arcadiapublishing.com
For customer service and orders:
Toll-Free 1-888-313-2665

Visit us on the internet at http://www.arcadiapublishing.com

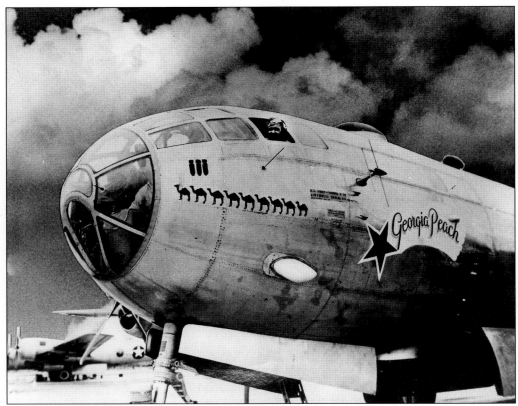

Pictured above is the *Georgia Peach*—a B-29 bomber built at the Bell Bomber Plant in Marietta, Georgia.

CONTENTS

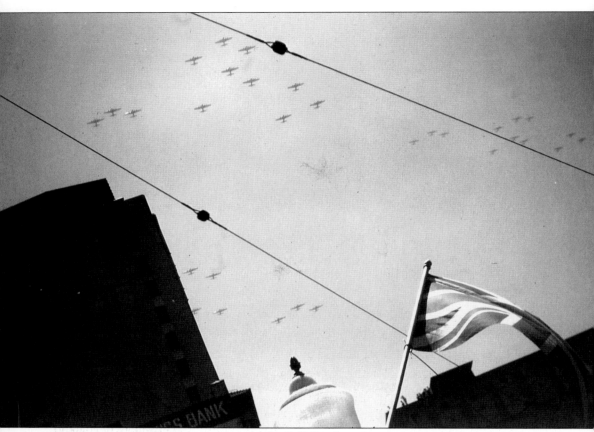

B-29 bombers, fresh off the runways of the Bell Bomber plant, soar over downtown Atlanta in salute to Gen. Courtney Hodges and other Georgia veterans of the First Army after their return from Europe in May of 1945.

INTRODUCTION

Few historical events shaped the city of Atlanta more than World War II. A hub for the Civil Rights movement in the 1950s and 1960s, Atlanta is now home to over four million people and serves as national headquarters for a dozen Fortune 500 companies. It would never have developed to such prominence, however, without the Allied victory in the global conflict. Through photographs selected from the collections of the Kenan Research Center at the Atlanta History Center, *World War II in Atlanta* examines the war's role in creating today's vibrant, sprawling megalopolis with its diverse population.

Initially, this book explores the effects of the Great Depression and New Deal reforms as Atlanta struggled through one of the most difficult times in its history. Photographs of Franklin D. Roosevelt during his visits to Atlanta and other Georgia cities document his ties to the state and the "Little White House" in Warm Springs. Images from the home front include war bond advertisements, Bob Hope at a USO show, and victory garden promotions. From women on the line at the Marietta Bell Bomber plant to dances for soldiers at the YMCA, Atlantans did their part through sacrifice and accomplishment.

This book presents photographs of military training and operations in Georgia that show the scope of the armed forces' preparations for conflict in the European and Pacific theaters. The two warships named *Atlanta* as well as the Liberty ships named for famous Atlantans illustrate the symbolic connections between the city and the war. In addition, portraits and personal stories of some of Atlanta's sons and daughters who served in the war highlight the human side of the conflict.

The final chapter tells the story of how Atlanta was transformed from a regional Southern city into a major industrial metropolis as a result of the economic and political changes brought about by the New Deal and World War II. Industrial growth, highway construction, and suburbanization dramatically changed Atlanta from the city it had been in 1930. For African Americans and others, the idealism of the fight abroad resonated with struggles at home, leading to the early stages of the modern Civil Rights movement, which focused on voter registration drives and the inequalities of city services and health care.

From personal sacrifices to mobilization to industrial expansion, World War II reached into every corner of Atlanta. In fighting a global war, Atlantans reshaped their world at home.

By 1930, severe erosion, over-tilled land, soil depletion, the boll weevil, and the Depression severely damaged Georgia's agricultural economy. Millions of acres of former cotton land were abandoned throughout the state, and the number of farms fell dramatically. Many of these farmers migrated to Atlanta, burdening an already weak urban economy.

One

THE DEPRESSION AND THE NEW DEAL

During the 1920s, Atlanta was a city on the move, a thriving center of commerce and transportation sustained by phenomenal economic growth that sustained an ever-expanding middle class. But like the rest of the nation, the city was hit hard by the stock market crash of 1929. An era of prosperity and optimism gave way to a prolonged economic depression that affected virtually everyone.

Those at the bottom of Atlanta's economic ladder suffered the most. Low wages and wretched living conditions persisted as the city absorbed refugees from Georgia's rural areas, already reeling from a decade-long drop in agricultural prices. Despite its well-earned status as one of the South's most progressive cities, Atlanta still faced a number of intractable problems. Among them were a crumbling infrastructure and a chronic shortage of hospitals, schools, and charities exacerbated by a "separate but equal" system that awarded the lion's share of resources to whites and a pittance to blacks.

Into the breach stepped the federal government and the New Deal with a vast array of economic and social programs. Among the most significant were those offering temporary relief to the unemployed through public works projects largely administered through the Works Progress Administration (WPA) and the Civilian Conservation Corps (CCC). Thousands of men and women in Atlanta and throughout the state of Georgia were put to work building roads, bridges, sewer systems, buildings, and playgrounds. The New Deal went beyond providing jobs during the Great Depression. It was intended as a massive economic reformation that would bring higher living standards to all Americans, including those of African descent, a radical notion in the Deep South of the 1930s.

While innovative government programs put people back to work and alleviated some of the human suffering, they failed to end the Depression. Dismal economic conditions persisted throughout the decade, and many whites who administered federal programs in the South discriminated against African Americans. But the New Deal did offer hope, especially for blacks and poor whites. Federal programs challenged racial concepts in Atlanta and throughout the South by providing equal wage scales for blacks, and many white factory workers and farmers finally felt they had a powerful ally. Moreover, the public works programs left behind an improved infrastructure that better prepared the city for growth during and after World War II.

A billboard on Peachtree Street encourages economic activity. Atlanta, like the nation, experienced declining business activity and a stagnated economy. Everyone—from the rich to the poor—felt the impact of declines in construction and retail sales.

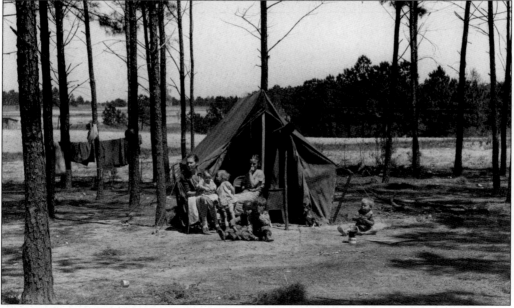

Migrant families dotted the landscape throughout the country, particularly around cities near major rail lines like Atlanta. Photographer Marion Post Wolcott of the Farm Security Administration (FSA) discovered this mother and her six children camped near Atlanta. Images like these from Wolcott and other FSA photographers captured the public's attention and helped increase support for New Deal policies.

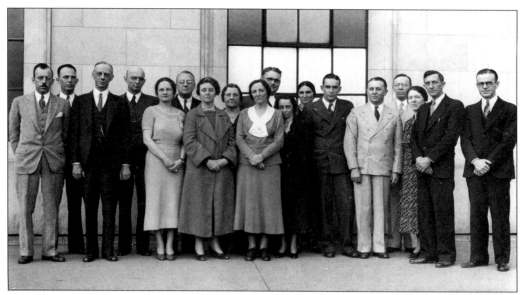

Gay Shepperson (center, white collar) is flanked by employees of the Georgia Civil Works Administration. When President Franklin Delano Roosevelt took office in 1933, the government initiated temporary relief programs under the Federal Emergency Relief Administration to alleviate the effects of the Depression. The Georgia Relief Commission, headed by Shepperson, initially administered federal relief funds.

Political battles over New Deal policies in Georgia erupted constantly. Gov. Eugene Talmadge opposed Shepperson's efforts to administer relief funds, preferring to use federal funds to bolster his political machine. Talmadge lost the governorship in 1936, but regained it in 1940.

What
The Blue Eagle
Means

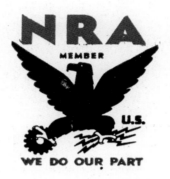

For Public and Private Schools
In Atlanta and Fulton County
N R A P L E D G E D A Y
October 4th, 1933

Compiled by
THE ATLANTA GEORGIAN AND SUNDAY AMERICAN

Atlanta city officials appealed to citizens to support the National Recovery Administration (NRA), a federal relief agency created to help revive industry and fight unemployment. The NRA established over 500 fair practice codes for industries relating to work hours, pay rates, and price-fixing. Also, employees gained the right to organize and bargain collectively. Businesses that voluntarily complied with the codes were entitled to display the Blue Eagle, the emblem signifying NRA participation.

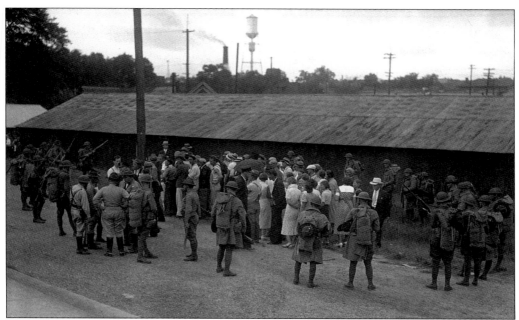

Striking textile workers from the Newnan Cotton Mills are rounded up at Fort McPherson by the Georgia National Guard on the orders of Governor Talmadge. The Newnan employees were part of a massive nationwide strike by the United Textile Workers of America after numerous complaints that employers were violating NRA industry codes.

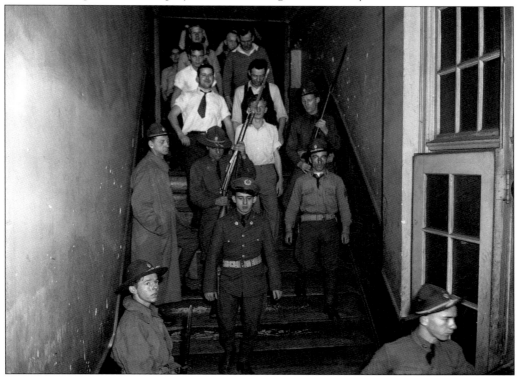

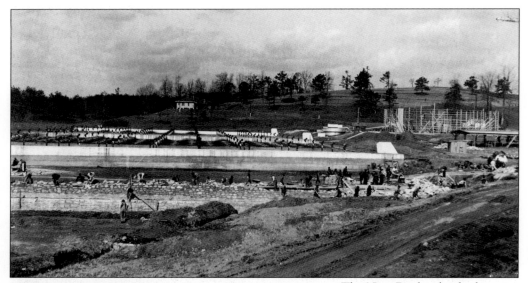

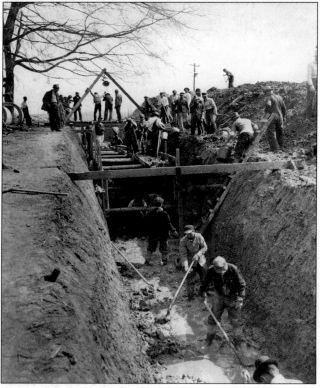

The New Deal unleashed an avalanche of federal funds for public works projects throughout the 1930s. Atlanta received over $7 million from the Works Progress Administration (WPA) to build a new sewer system and new schools and to implement improvements to the airport, libraries, roads, and hospitals. Thousands of unskilled, out-of-work Atlantans were put to work rebuilding Atlanta's crumbling sewer system, which was an embarrassment to the city and a health hazard to its citizens. Farmers who used local streams for livestock sued the city for neglect of its waterways, which were polluted with industrial and human waste. Disposal plants were full, and even moderate rainfalls flooded streets and basements.

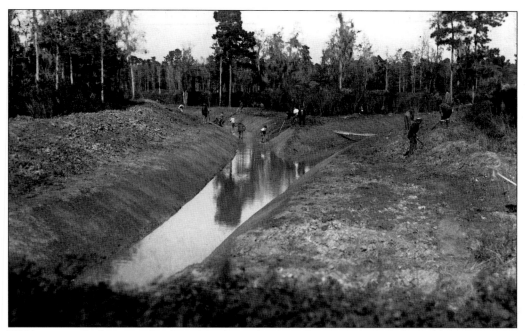

WPA crews ditch swampland in Chatham County, Georgia, part of the Malaria Drainage Project. The state's numerous swamps and waterways were breeding grounds for malaria, typhoid, and hookworm.

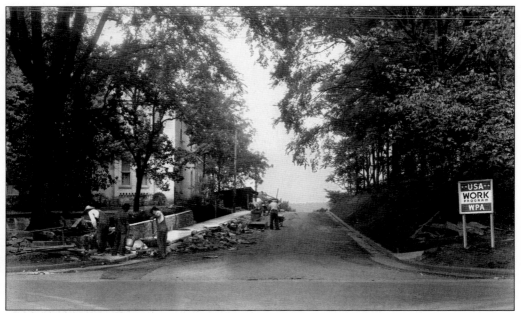

The WPA spent millions in improvements to roads and highways.

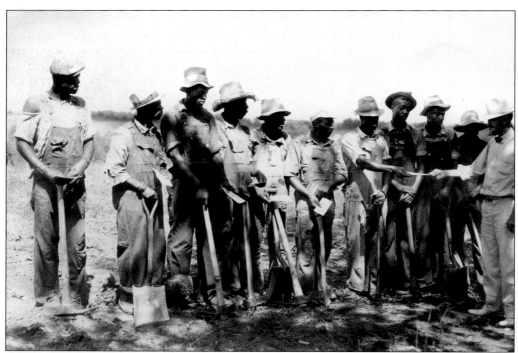

Drought relief workers in Forsyth, Georgia, receive checks from the government. The economic woes of the nation's farms were compounded by severe drought, the worst in U.S. history. Farmers received direct aid or were taught farming methods to compensate for the drought.

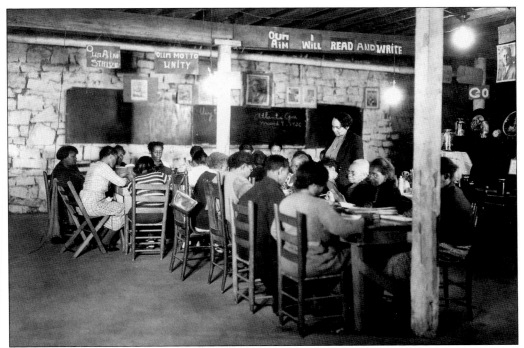

A WPA literacy class at Atlanta's Mt. Zion Baptist Church teaches reading skills. The New Deal marked a shift in attitudes among the reform-minded in Georgia to include African Americans in federal programs. An acknowledgment of their needs marked an important step on the road to full citizenship for African Americans in Georgia and throughout the South.

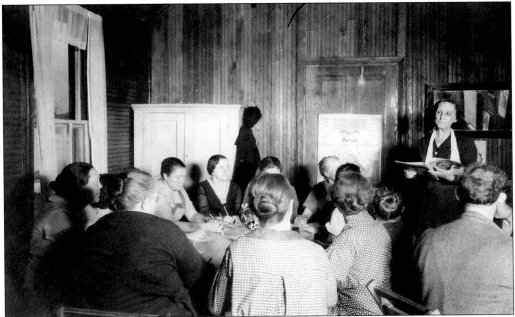

An instructor teaches the basics to students at an adult literacy class for whites. Most New Deal programs throughout the South were segregated by race.

The WPA offered vocational training in agriculture, art, and domestic services.

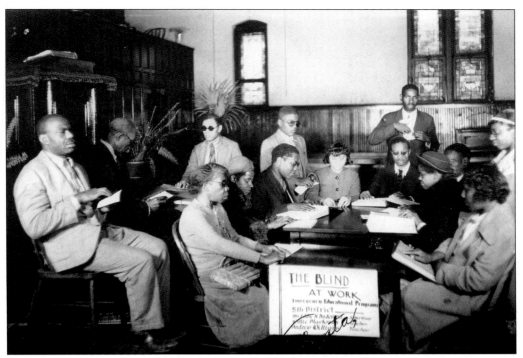

The education program of the WPA taught the blind to read braille.

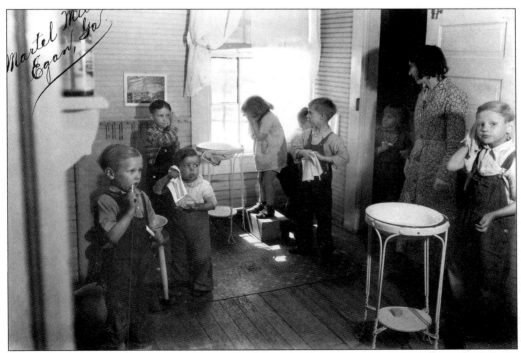

The nursery project established nurseries for children of low-income parents, allowing adults to seek employment. An instructor at this nursery makes sure the children are well groomed.

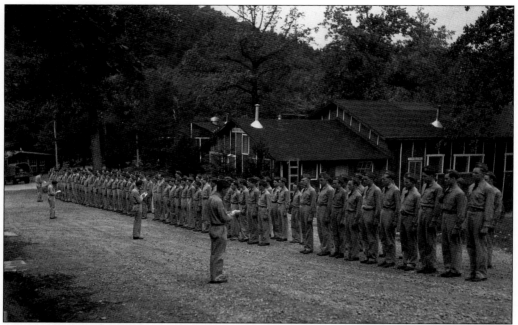

Officers call roll at one of Georgia's Civilian Conservation Corps (CCC) camps. At the height of its popularity, the CCC employed nearly 500,000 men and boys nationwide to restore and develop the nation's forests, build roads, and work on erosion control.

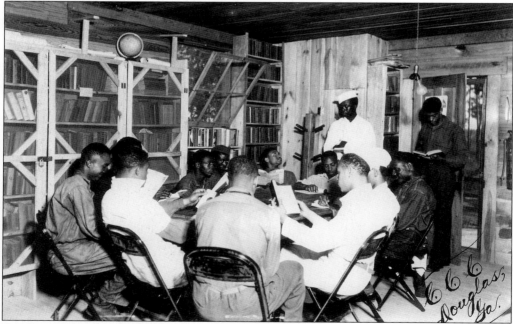

Youths take part in educational opportunities at a South Georgia CCC camp. By 1934, the CCC was entirely segregated; whites often complained bitterly when a camp staffed by black men and boys was built anywhere near town. Over 200,000 African Americans served their country in Civilian Conservation Corps camps.

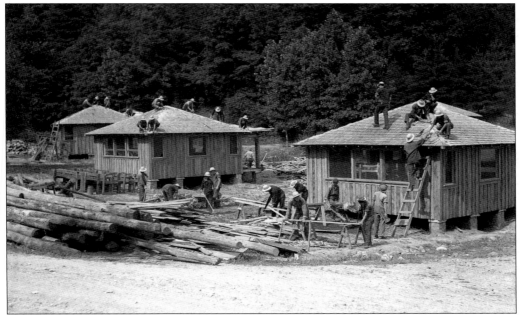

The "CCC boys" are hard at work building a campsite in the forest. Sometimes called "Roosevelt's Tree Army," the CCC was composed of young men who lived in camps throughout their term of service, much like soldiers in an army. Each camp had a commanding officer, usually a lieutenant or colonel in the United States Army. The corps operated over 30 camps throughout Georgia from 1933 to 1942.

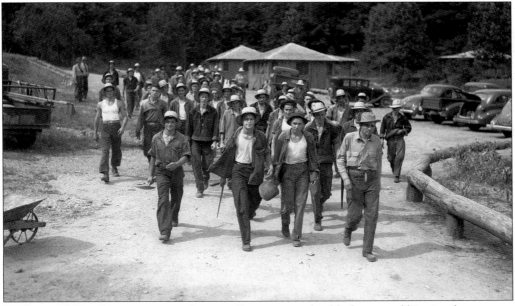

In all, over 2.5 million young men from small towns, ramshackle farms, and big city slums across the nation enlisted in the CCC. For their labor, the young men got "three squares a day," a roof over their head, and $1 a day, most of which they sent home. Under the rules, men between 18 and 25 had to turn over the bulk of their earnings to their families.

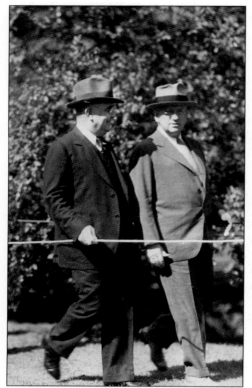

In the 1930s and 1940s, policymakers viewed slum removal and public housing as remedies to reduce crime and disease in poverty-stricken areas. The nation's first federal public housing projects were built in Atlanta when the Public Works Administration approved funds to construct two developments. Atlanta real estate investor Charles Palmer, along with Atlanta University president John Hope, persuaded federal officials to build University Homes for blacks and Techwood Homes for whites. In the fall of 1934, Harold L. Ickes (facing camera), Roosevelt's secretary of the interior, visited Atlanta to take part in ceremonies that marked the beginning of slum clearance by detonating dynamite charges at both sites. In the image below, a photographer is caught the blast in the Beavers Slide neighborhood, a west side neighborhood close to the Atlanta University Center colleges. (General Photograph Collection, Atlanta University Center, Robert W. Woodruff Library.)

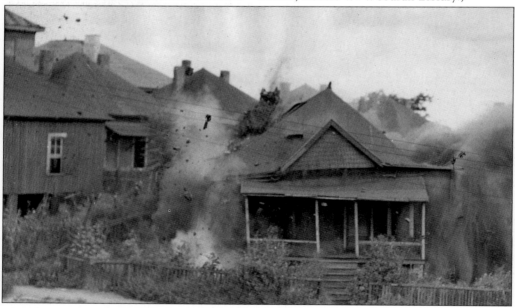

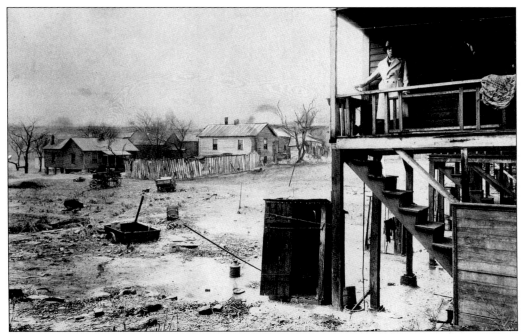

Techwood Homes were built in a neighborhood known as Tanyard Bottom or Techwood Flats, adjacent to the Georgia Tech campus and close to busy Peachtree Street. Rat infested and composed of barn-like buildings and swampy backyards, this blighted and very visible area had been a public eyesore for decades.

When Techwood's first residents moved into their new homes in 1936, builders had transformed "the Flats" into a freshly landscaped, modern residential complex complete with brick buildings, sidewalks, and paved streets. Although federal subsidies usually assured low rents, Techwood Homes commanded the highest prices in the South region with larger units selling for $38 per month. Community support for public housing projects like Techwood produced applications for several other similar housing projects.

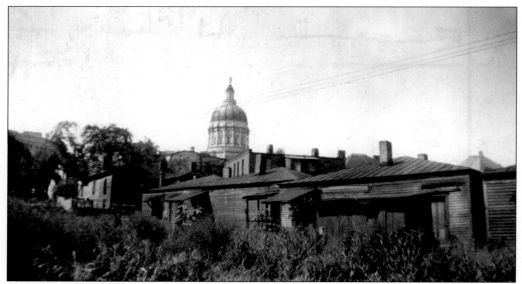

Many of Atlanta's poor lived in dilapidated shacks like these in the shadow of the state capital. Most were built before 1915, and some before the Civil War. Four out of five lacked either an inside bath or running water. The large number of these types of homes mixed with the belief that slum clearance would improve social conditions spurred the creation of the Housing Authority of Atlanta in 1938 to begin eliminating the slums.

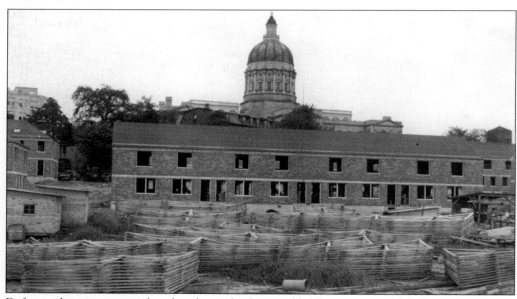

Deficient housing was replaced with sturdy, fireproof brick structures. This photograph shows the construction of Capitol Homes in downtown Atlanta.

A farmer wades through a bountiful cotton crop in the Pine Mountain Valley Community in West Georgia near President Roosevelt's home in Warm Springs. In 1934, the Federal Emergency Relief Administration purchased 10,000 acres to establish a cooperative community populated by the unemployed from Georgia's cities. Three-hundred families were relocated on this development with the hope that it would become a self-sufficient community.

Here is one of several hundred families who were chosen for the Pine Mountain Valley Project. Instead of receiving direct relief payments, the settlers (called "colonists") would be paid to work in small factories or stores, or to build homes, gardens, and other facilities needed to create a self-sufficient agricultural community.

Children tend to the garden of a settler's home in the community.

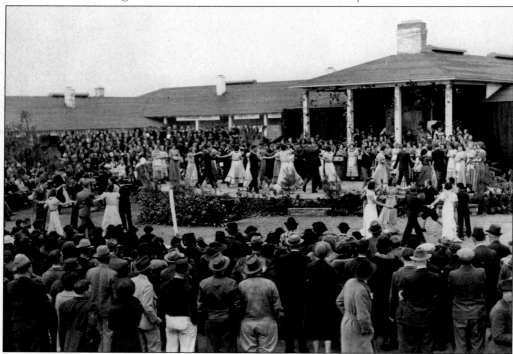

Pine Mountain Valley settlers celebrate Thanksgiving in 1937 with their guests amid the music of "Happy Days Are Here Again." The colonists were celebrating their first bumper crop with an elaborate festival complete with dancing and exhibits highlighting the community's agricultural yield.

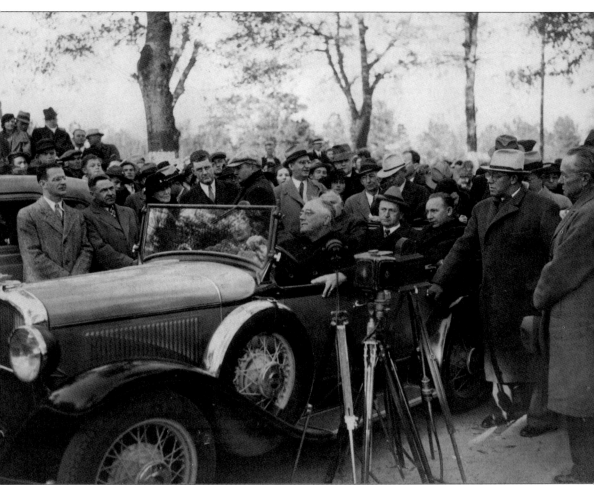

Pine Mountain Valley residents welcome President Franklin D. Roosevelt shortly after the community's inception in 1935. The president praised the cooperative experiment as "a dream come true." In the backseat of the president's car are (left to right) Cason Callaway, textile manufacturer and close friend of the president's; Philip Weltner, southeastern director of resettlement rehabilitation (Weltner would go on to serve in the U.S. House of Representatives and the Georgia Supreme Court); and Richard Morris, project manager of the Pine Mountain Community. Although the Pine Mountain experiment ultimately failed, many settlers eventually bought their homesteads, and today the valley is one of Georgia's sturdy rural communities.

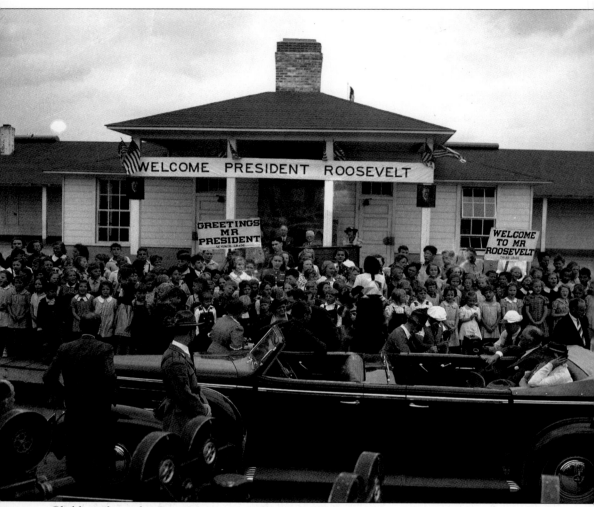

Children from the Pine Mountain Valley School, just a short drive from the "Little White House" in Warm Springs, welcome President Franklin D. Roosevelt with a song during a springtime visit to the community in 1938. The woman seated next to him is his secretary, Marguerite Leland.

Two

OUR FRIEND
AND NEIGHBOR

Franklin Delano Roosevelt established a relationship with the people of Georgia long before he became president and led the political revolution of the 1930s. Roosevelt's special bond with the people of the Peach State began in the 1920s during his many visits to the town of Warm Springs, where he became a part-time resident. Throughout his 12-year presidency, Georgians showered the "Yankee" politician with more support and enthusiasm than they had shown for any Northern president since before the Civil War. His dynamic personality and soothing radio chats were a calming influence throughout the Depression, and his successful leadership against the Axis powers in World War II cemented his reputation as one of the nation's most popular and respected Presidents.

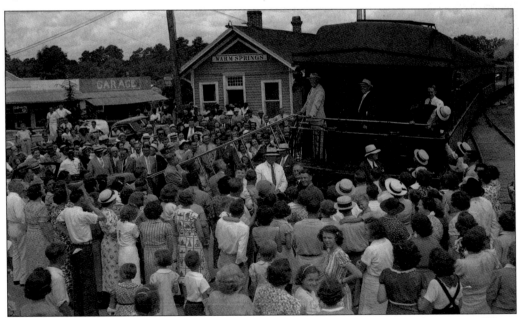

Friends and neighbors of President Roosevelt gather to say goodbye after another visit to Warm Springs. FDR made over 40 trips to the Georgia town between 1924 and 1945.

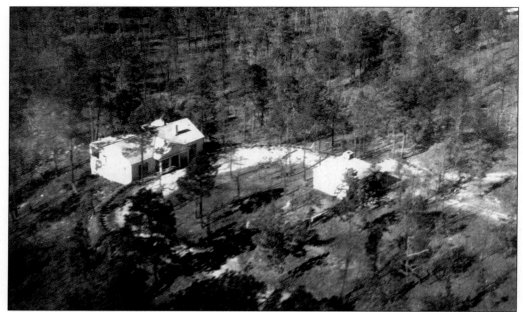

Above and below are two views of Franklin Roosevelt's home in Warm Springs, Georgia, a resort town with mineral water pools that provided healing warmth for victims of polio and relaxation for well-heeled vacationers. Roosevelt first visited the spas of Warm Springs in 1924, three years after polio paralyzed his legs. Shortly thereafter, he purchased over 1,000 acres of woodland and a few cottages that he later transformed into an internationally known treatment center for polio victims. Grateful for Roosevelt's charitable contribution and swept away by his charm, many Georgians adopted the governor of New York as their "favorite son" candidate for president in 1932. During the weeks before his inauguration, his Warm Springs home gained the title "Little White House" for the time he spent there planning his administration.

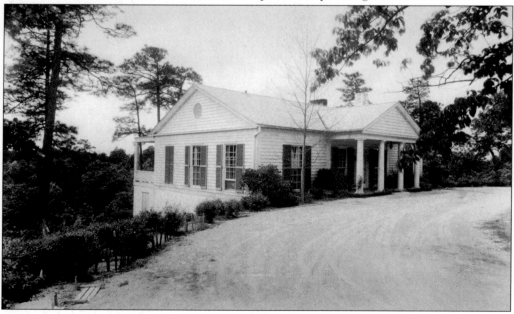

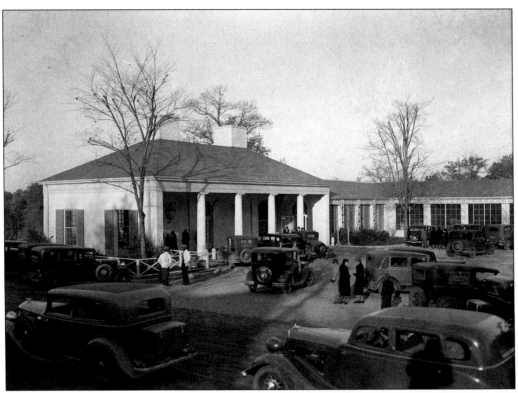

FDR expanded the resort property that he bought in 1926 into a therapeutic center for polio patients. The nonprofit Georgia Warm Springs Foundation was created to operate the facilities. This is Georgia Hall. Built in 1933 with the donations of over 60,000 Georgians, it was the first of more than 20 structures built on the campus.

Patients are pictured inside Georgia Hall. Sparked by FDR's legacy, the March of Dimes led the way in raising funds for a vaccine that effectively ended polio in the United States by the mid-1960s. Now known as the Roosevelt Warm Springs Institute for Rehabilitation, it features state-of-the-art recreational facilities, lodging for patients and families, a golf course, and a chapel.

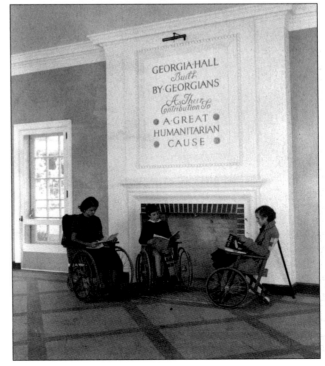

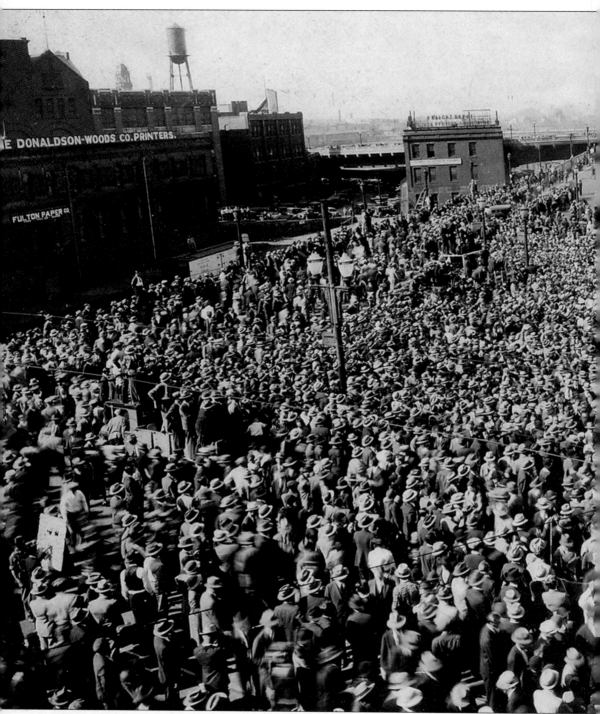

Thousands of enthusiastic supporters gathered on a Sunday morning in front of Atlanta's Union Station to welcome Roosevelt during the presidential campaign of 1932. The Democratic nominee visited Georgia's capital city during a late campaign swing through the

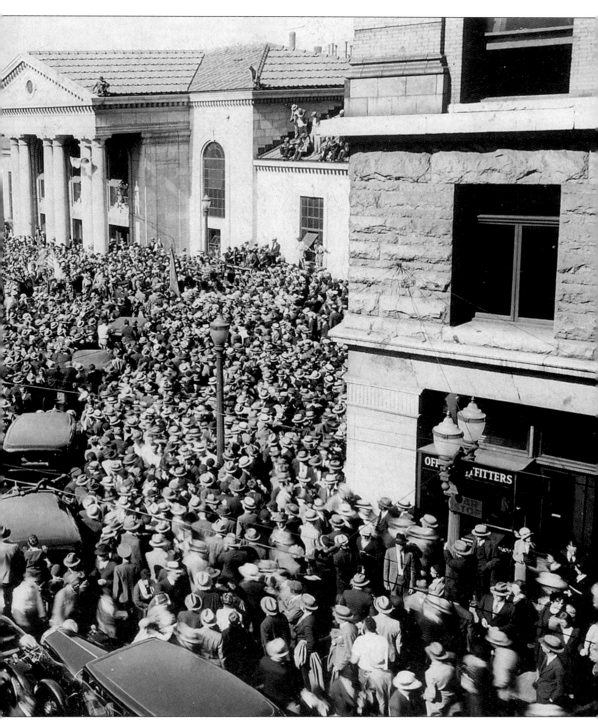

South in October. Two weeks later, FDR defeated his Republican rival, President Herbert Hoover, in a landslide election. Residents of Atlanta's Fulton County voted ten-to-one in favor of Roosevelt.

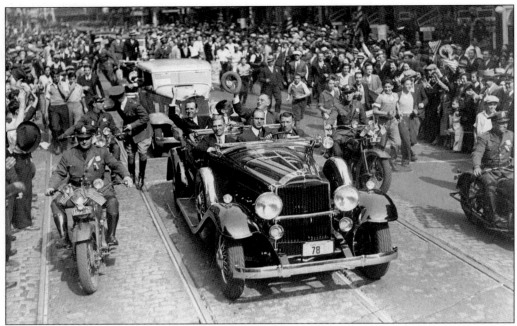

Governor Roosevelt tips his hat in acknowledgment of the friendly greetings from well-wishers lining a parade route along Peachtree Street. In his car, left to right, are (rear seat) Georgia senator Richard B. Russell Jr.; Hugh Howell, chairman of the Georgia State Democratic Committee; and Roosevelt. In the front, from left to right, are Mayor James Key, James Roosevelt, the nominee's son, and driver Alvin S. Belle Isle, an Atlanta businessman.

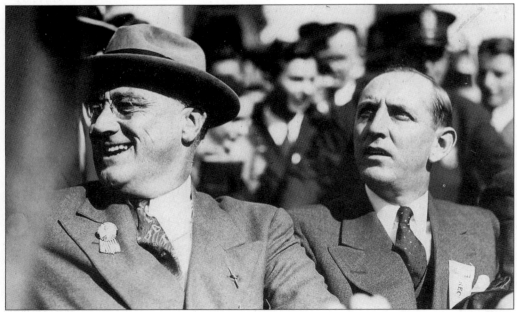

The governor and senator-elect of Georgia, Richard Russell is pictured here with Roosevelt. One month before Roosevelt's arrival in Atlanta, Russell won a special election to fill the Senate seat held by William J. Harris, who died of a heart attack.

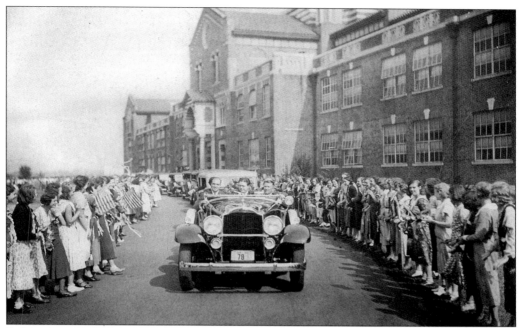

Before the parade down Peachtree Street, Roosevelt's tour took him to most of Atlanta's high schools. Admiring students (above) at Atlanta's Girls High welcome the candidate to their campus, while (below) an enterprising student catches up to FDR's motorcade to shake the candidate's hand. One of Atlanta's elite preparatory schools, Girls High changed its name to Roosevelt High in 1947.

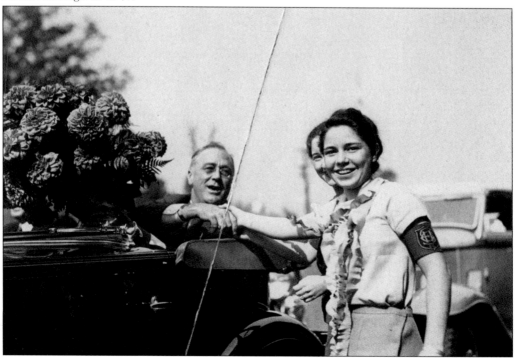

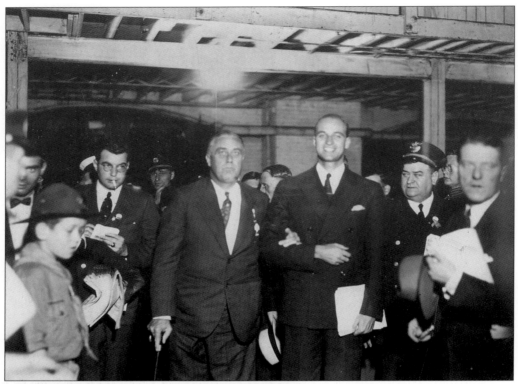

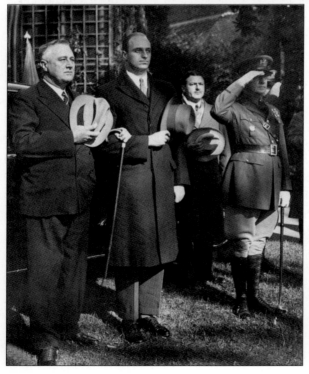

Roosevelt's oldest son, James Roosevelt, helps his father stand while posing for photographers in Union Station, one of Atlanta's train depots. With the press's assistance, Roosevelt and his aides were adept at concealing his physical condition from much of the American public.

FDR stands at attention while reviewing part of the Twenty-Second Infantry stationed at Fort McPherson in Atlanta. Roosevelt was in Atlanta to dedicate the opening of the Techwood housing project to a huge gathering at Georgia Tech's Grant Field in 1935. Seen from left to right in the photograph are Roosevelt, his eldest son, James, and Maj. Gen. George Van Horn Moseley, commander of the Third Army.

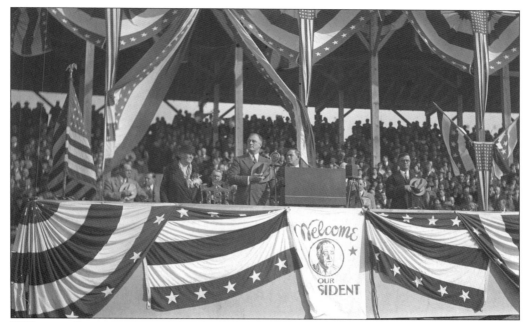

FDR joins Georgia governor Eugene Talmadge (right) on the speaker's stand in Savannah stadium for the state's bicentennial ceremonies in 1933. Roosevelt was the guest of honor in his first visit back to Georgia since his election a year earlier. Sara Delano Roosevelt, the president's mother, is on the left.

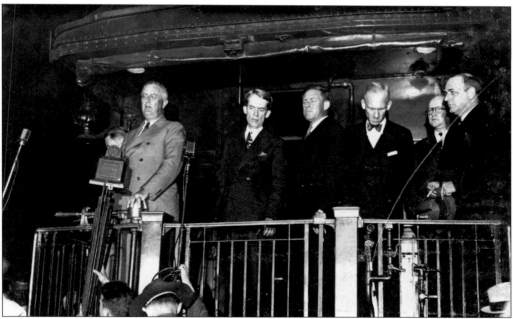

Roosevelt addresses the beleaguered citizens of Gainesville, Georgia, after devastating tornado winds ripped through the town of 10,000 on April 1936, killing 162. The president praised the town's spirit and commitment and pledged the federal government's help. Over $1 million in federal money was allocated to help rebuild the infrastructure and provide relief to victims.

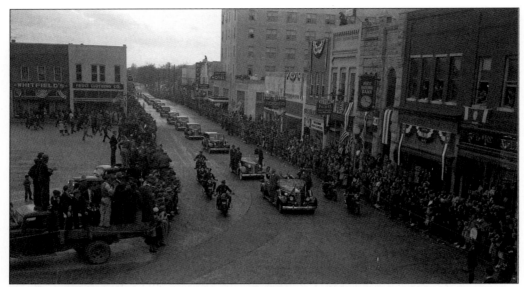

A rebuilt public square and rejuvenated spirit welcomed FDR for "Roosevelt Day" two years later in Gainesville. Flanked by a heavy detail of Atlanta motorcycle police, President Roosevelt's car leads a long parade of automobiles around the town's public square.

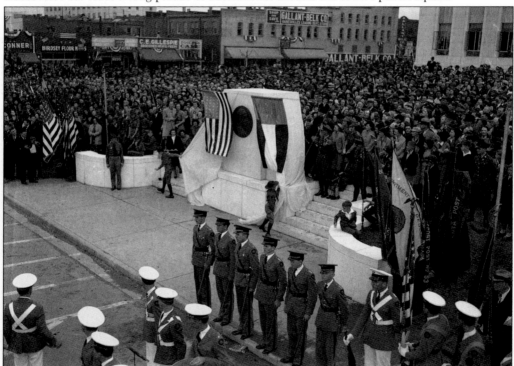

Two Gainesville Boy Scouts unveil a marble monument featuring a bronze likeness of President Roosevelt in honor of his leadership. The marble monument was draped by the American flag and the Georgia state flag. The unveiling marked the opening of the town's civic center in the newly named Roosevelt Square. An estimated crowd of 50,000 attended the ceremony.

Eleanor Roosevelt is shown at a WPA site in Georgia. The first lady was a valued political advisor to her husband. She is pictured here with WPA Administrator Harry Hopkins and an unidentified woman.

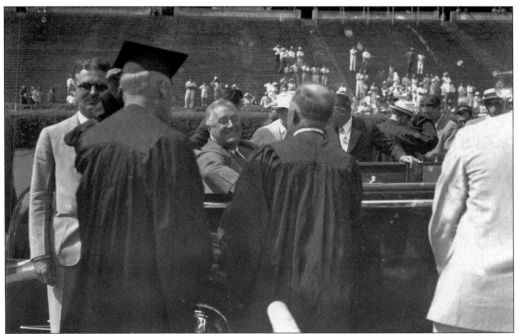

Cameras caught the arrival of the president in a Secret Service car for graduation at the University of Georgia on a brutally hot August day in 1938. Roosevelt accepted an honorary degree at ceremonies held in Sanford Stadium. Later that day, the president traveled to Barnesville, Georgia, to deliver a speech attacking the state's senior member of the Senate, Walter George.

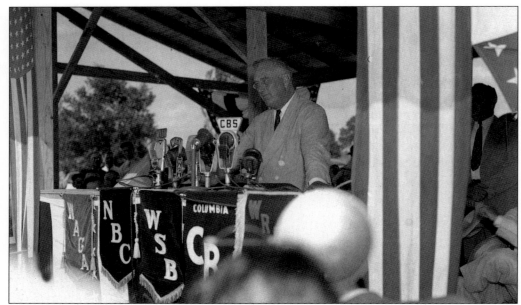

A speech in Barnesville intended to publicize the presidential accomplishment of affordable electric service in rural Georgia turned into a political imbroglio as Roosevelt launched a scathing attack on Sen. Walter George. A series of political defeats led by George and other conservative Democrats in Congress the previous year touched off the administration's attempt to defeat incumbents in its own party in favor of more liberal candidates.

Senator George (holding hat) squints and listens intently to FDR's endorsement of his opponent in the Democratic primary, United States Attorney Lawrence Camp, who is seated next to him on the right. Roosevelt's plea to Georgians to cast aside the senior senator ultimately failed. From left to right are (seated) Sen. Richard Russell, George, Camp, and Governor E.D. Rivers.

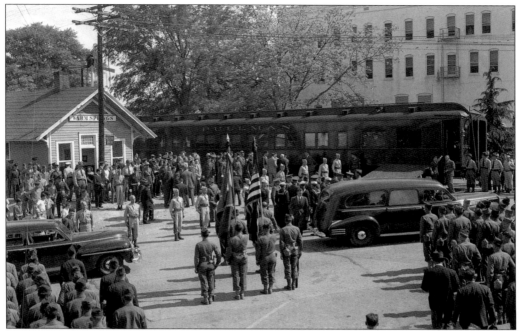

Sadness and shock gripped the nation with the announcement of the death of President Roosevelt in Warm Springs on April 12, 1945. At the town's train station servicemen stand at attention and mourners pay their last respects to their beloved neighbor while the hearse carrying his body motors past.

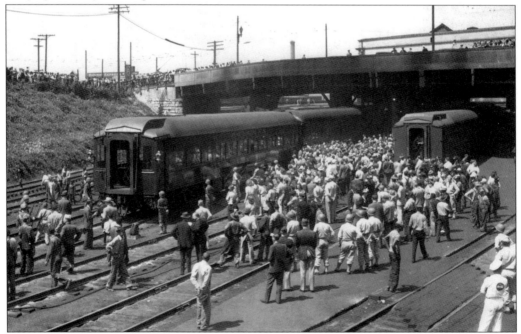

Roosevelt's 11-car funeral train pulls into Atlanta's Terminal Station for a 45-minute halt on its way to Washington, D.C.

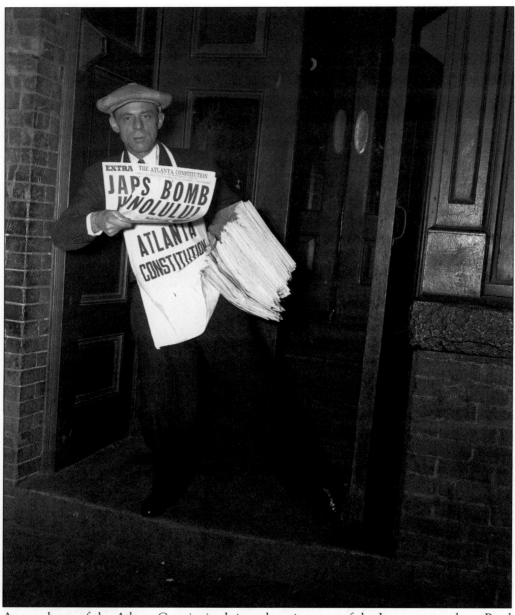

An employee of the *Atlanta Constitution* brings the grim news of the Japanese attack on Pearl Harbor that resulted in America's entry into World War II.

Three
ATLANTA MOBILIZES FOR WAR

The Japanese attack on American forces at Pearl Harbor unified the nation to defeat the enemy and defend the United States. Atlantans joined the effort with determination and enthusiasm as the city became the scene of intense activity. While thousands of citizens enlisted in the armed forces, an even greater number on the home front helped out by purchasing war bonds, conserving vital resources, and building bombers. Celebrities contributed by rallying their fellow citizens and lifting spirits. Municipalities organized civil defense programs and provided rest and relief for hundreds of thousands of soldiers on leave. When it was all over, Atlanta could celebrate a job well done.

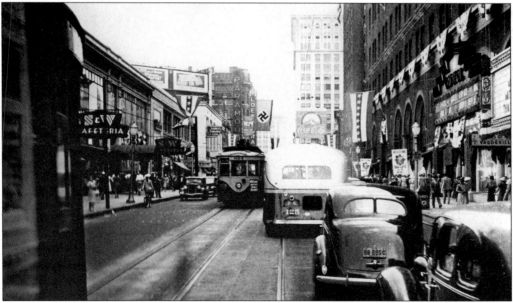

While the drumbeat of war was beating its loudest in Europe, religious leaders from all over the world convened in Atlanta at the sixth Baptist World Alliance meeting in July 1939. Flags of all the nations in attendance hung along the streets of downtown Atlanta, including that of Nazi Germany, shown here on Peachtree Street in the theater district. Five weeks after this photograph was taken, Germany invaded Poland and thus began the great six-year conflict.

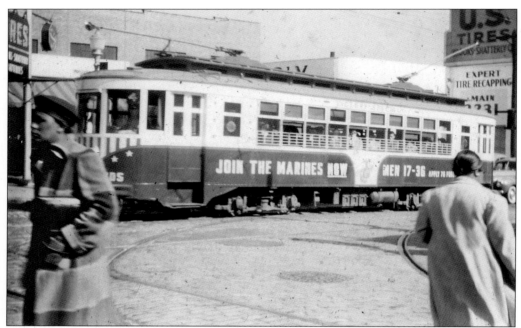

A trolley on the corner of Ivy (now West Peachtree) and Houston Streets carries an advertisement for the marines, most likely made shortly after the attack at Pearl Harbor.

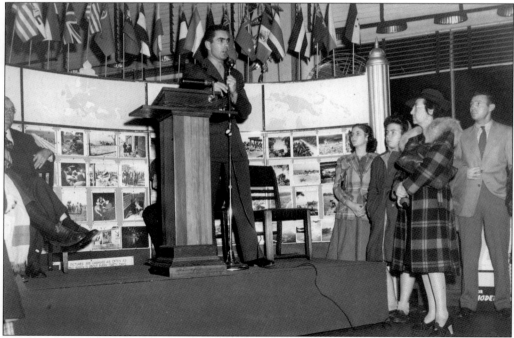

Actor and marine Tyrone Power makes an appearance at a war bond rally in Atlanta. War bond sales helped the government raise billions of dollars for the war in a combined effort of patriotism and civic responsibility. The war bond campaign financed the war, but it also lifted the morale of the American people by providing a financial stake in the country.

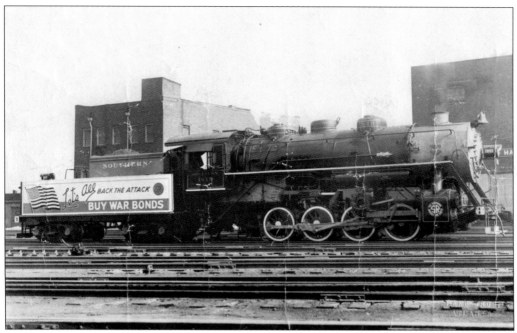

Selling war bonds to the public required a massive advertising campaign. Above, an ad on a Southern Railway switch engine at one of Atlanta's rail yards urges bond purchases, while (below) a trolley car on the Stone Mountain line partially obscures a soft drink advertisement for war bonds.

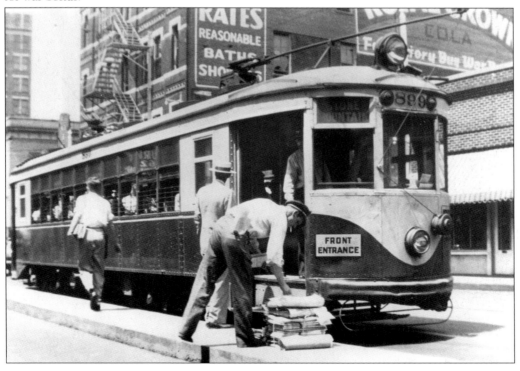

To compel the American public to cut back on consumption, the federal government introduced ration cards to purchase such items as food and gasoline. Ironically, an improved economy meant Americans finally had spending money, but restrictions were placed on goods available for purchase. When the war finally came to a close in 1945, industries returned to consumer production, and Americans went on a buying spree of unprecedented proportions.

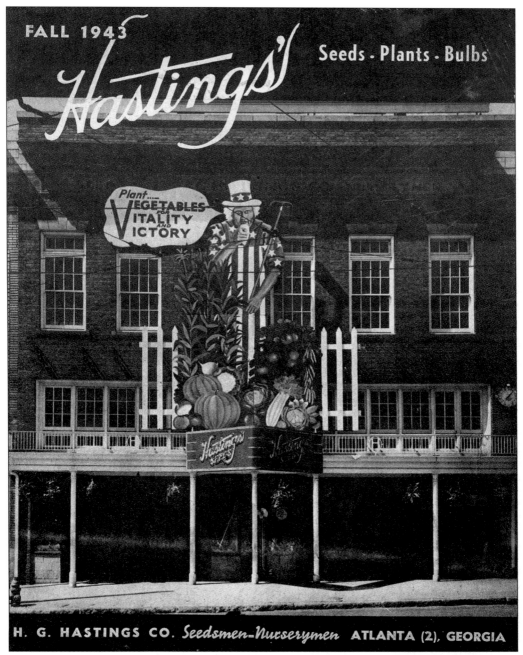

FALL 1943

Hastings'

Seeds · Plants · Bulbs

Plant....
VEGETABLES
for
VITALITY
and
VICTORY

H. G. HASTINGS CO. *Seedsmen-Nurserymen* ATLANTA (2), GEORGIA

One remedy to food shortages in the United States and abroad was homegrown vegetables. This was the philosophy of H.G. Hastings, the founder and chairman of the H.G. Hastings Seed Company, an Atlanta-based mail-order seed and nursery operation. Mr. Hastings urged his customers to plant "victory gardens" on their farms to avoid high food costs and support the Allied effort.

Celebrities, including Atlanta's most famous author, Margaret Mitchell, rallied support for the war effort. Mitchell was always ready to lend a hand, especially when the cause was associated with Atlanta. In addition to fund-raising for the Red Cross, she christened the United States cruiser *Atlanta* (see chapter five) and then led the drive to raise funds for a second ship after the first was sunk in 1942.

Actor and comedian Bob Hope pauses for comedic effect during a USO performance at the naval air station in Atlanta. The vaudevillian took his act on the road throughout World War II and beyond to the first Gulf War in 1991. In the summer of 1944 he toured the islands of the South Pacific to entertain the troops. He logged over 30,000 miles and gave more than 150 performances that year alone. In 1997, he was designated an honorary veteran by Congress. He is the only individual in history to have earned this honor.

Al Jolson attends a war loan rally at the Bell Bomber plant in Marietta.

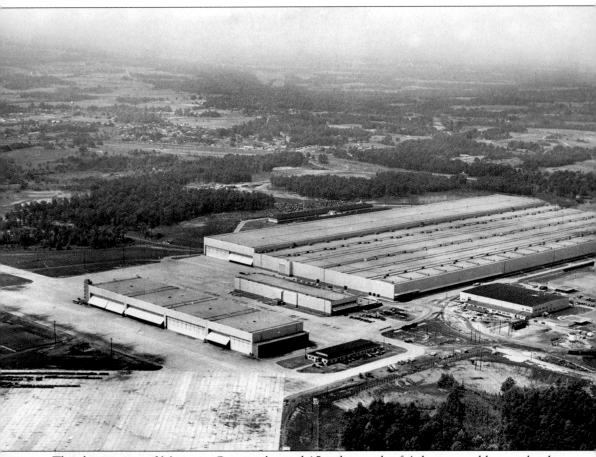

The sleepy town of Marietta, Georgia, located 15 miles north of Atlanta, would never be the same after the United States Army and the Bell Aircraft Corporation announced plans for the construction of a $15 million bomber plant in 1942. Atlanta would never be the same, either. Georgia's biggest and busiest wartime enterprise was the third largest of its kind in the United States, covering 70 acres of real estate.

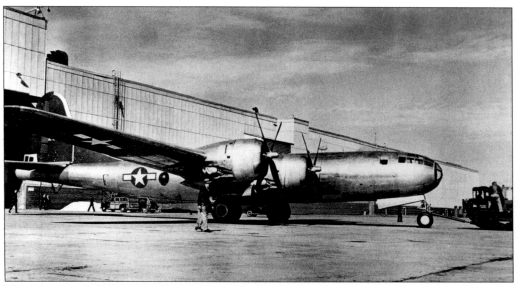

The Marietta Bell Bomber plant produced B-29s for the U.S. Army. This was the first B-29 built in Georgia just off the assembly line and towed out of the factory onto the flight test apron in December 1943. Hundreds of B-29s were built at the Marietta plant. Many of them were used against Japanese targets and other locations in the Pacific theater from June 1944 to August 1945, when two B-29s, the *Enola Gay* and *Bocks Car*, dropped atomic bombs on Hiroshima and Nagasaki, effectively ending the war.

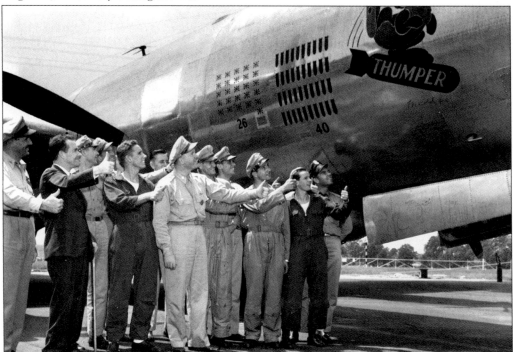

This is the B-29 super fortress, *Thumper*, and its crew, resting on the runway of the Bell Bomber plant. This plane flew 40 missions over Japan.

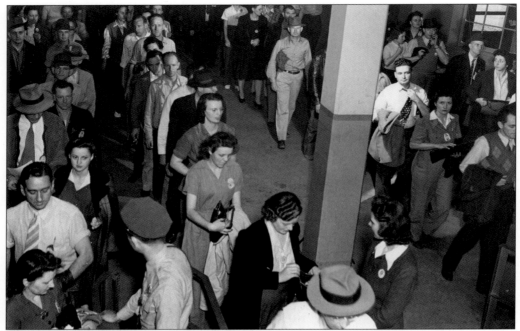

The Bell Bomber plant was an economic boon for the city. At the peak of production, the mammoth defense plant employed nearly 30,000 Georgians, mostly white. Its sheer size and output gave the people of Georgia a close-up view of the nation's tremendous war effort.

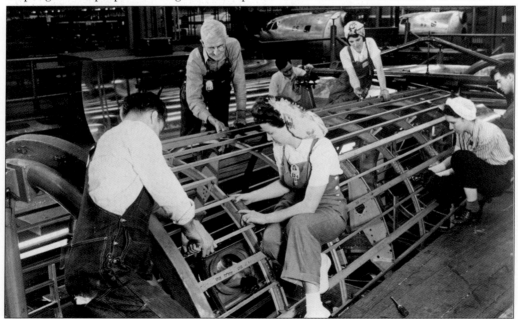

The fuselage section of a B-29 at the Bell Bomber plant is under construction. More than half of the work force at the Marietta Bell Bomber plant were women. In defense plants all over the country, women employees took on new work roles and played a major part in the ultimate success of the B-29 and other defense initiatives.

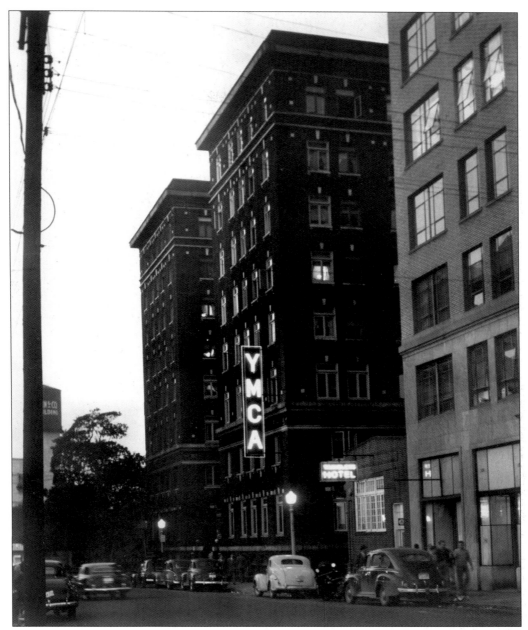

Atlanta was a popular destination for soldiers on leave. Troops housed on military bases within a 300-mile radius poured into the city on a daily basis. Realizing the logistical nightmare on their hands, city officials designated the local office of the United Service Organization (USO) to help locate facilities and set up new programs for the welfare and recreation of members of the armed forces. Locally, the USO was an umbrella organization for six agencies, including the Young Men's Christian Association (YMCA). White servicemen were housed here at the YMCA building on Luckie Street. The YMCA on Butler Street was designated for black servicemen, before the construction of a service center on Hunter Street. Over one million soldiers were hosted in facilities between 1941 and 1945.

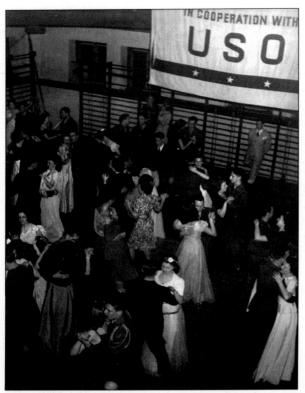

Saturday night dances at the YMCA were the most popular programs for troops, often highlighting their brief stay in Atlanta. Volunteers from women's service organizations served as hostesses, chaperones, and dance partners for grateful GIs. In addition, the USO offered information on sightseeing, entertainment at the Y, and church services. Individual Atlantans also extended their hospitality by inviting servicemen into their homes for dinner.

The USO center on Hunter Street operated from 1942 to 1946. It sponsored athletic contests, dinners, musical presentations, and Saturday night dances usually attended by hostesses and volunteers from nearby colleges including Spelman, Clark, and Morris Brown. (Lane Brothers Collection, Photographic Collections, Special Collections Department, Pullen Library, Georgia State University.)

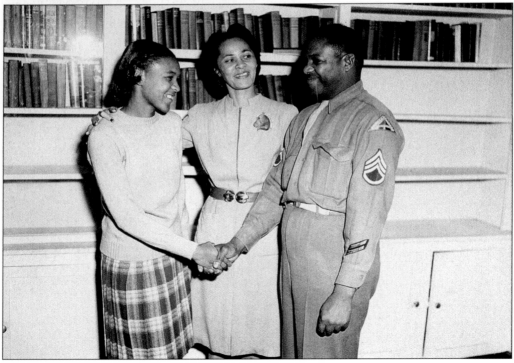

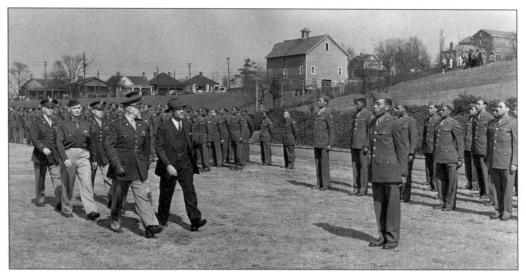

Soldiers stand at attention as Atlanta University president Rufus Clement and unidentified military officers review troops of the Army Administration School, a training ground for administrative and support staff for African-American units in the armed forces. Atlanta University, Morehouse College, and Clark College participated in the operation beginning in 1942. (Atlanta University Photographs, Atlanta University Center, Robert W. Woodruff Library, Griffith J. Davis, Photographer.)

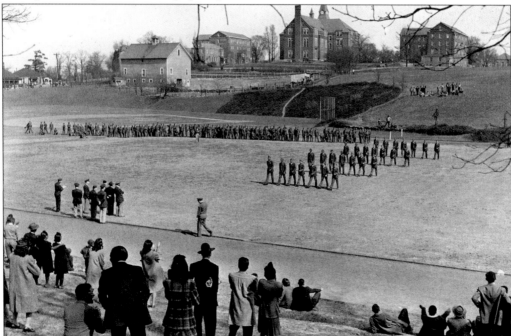

Army Administration enlistees march in formation on what is now Panther Field, the football and track and field facility at Clark-Atlanta University. Overlooking the field are the academic and administrative buildings of Morris Brown College. (Atlanta University Photographs, Atlanta University Center, Robert W. Woodruff Library, Griffith J. Davis, Photographer.)

In this photograph is Lillian Nelson (left), president of the Georgia State Nurses Association, along with Georgia cadets in the Army Nurse Corps. To absorb the impact of American casualties, hundreds of Georgia's nurses volunteered or were drafted into the Army and Navy Nurse Corps during the war.

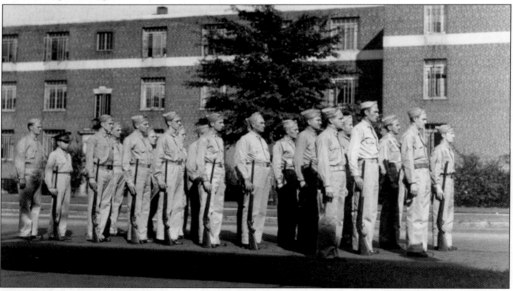

A Georgia State Guard unit pictured above in formation at Techwood Homes in Atlanta in 1942. Within one hour of the bombing of Pearl Harbor, a state guard unit was on duty at the Atlanta City Water Works, the first guard unit in America to go to war. Organized for civilian defense, its headquarters was at the Techwood housing project with 375 members, most of whom were tenants.

What to do about your GAS SERVICE during

AIR RAIDS and BLACKOUTS

Keep this important thought in your mind about your gas service during BLACKOUTS—and during AIR RAIDS, if they should come to Marietta:

Use your gas service as you do normally—
with the two exceptions listed below:

EXCEPTIONS—

(1) Turn off lighted top burners on your gas range, radiant heaters or any open flame heater that may be seen from the outside.

(2) In the event your home is badly damaged, turn the gas off at the meter.

CAUTION:

Once the gas is turned off at the meter *do not attempt to turn it back on yourself.* Call for a trained man from the Gas Company to restore your gas service.

Now one important "Do Not," about pilot lights—
DO NOT turn out pilot lights

Here's why: When you turn out the pilot lights on your gas range, water heater, refrigerator, furnace or other heating appliances, you needlessly interrupt these essential gas services.

Help us help you, by following these simple instructions. You will avoid unnecessary confusion and inconvenience in your home, if you'll *just remember to use your gas service as you do normally*, during BLACKOUTS and possible AIR RAIDS—with the two exceptions set out above.

ATANTA GAS LIGHT Ⓞ COMPANY

The warning on this flyer is an example of one of many precautions taken by the Atlanta Gas Light Company during World War II. Marietta and Atlanta officials and residents believed the city was a legitimate target for enemy planes because of the presence of the Bell Bomber Plant.

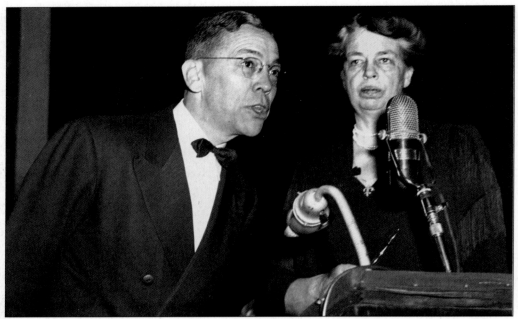

Atlanta mayor Roy LeCraw shares the stage with First Lady Eleanor Roosevelt as she fields questions on civilian defense from an audience of more than 5,000 at the city auditorium. Mrs. Roosevelt urged the participation of every Georgia citizen in the war effort, claiming the best defense starts at home.

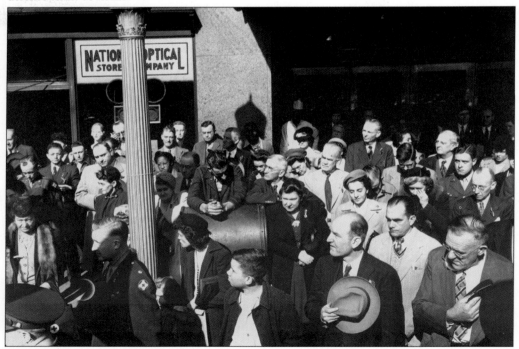

To the somber notes of "Taps," several hundred Atlantans gathered at Five Points to pause in prayer for those killed in both world wars on Armistice Day, November 11, 1944.

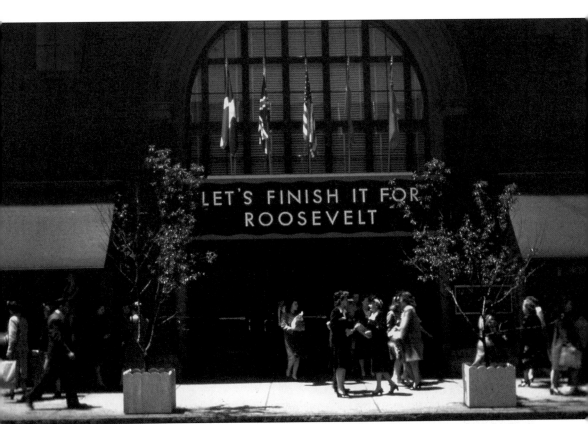

Smart shoppers traverse the downtown sidewalks along Peachtree Street under a sign at the entrance to Davison's department store urging Atlantans to finish the great struggle for the late president. With the surrender of Adolf Hitler's army, the Allied focus shifted to Japan.

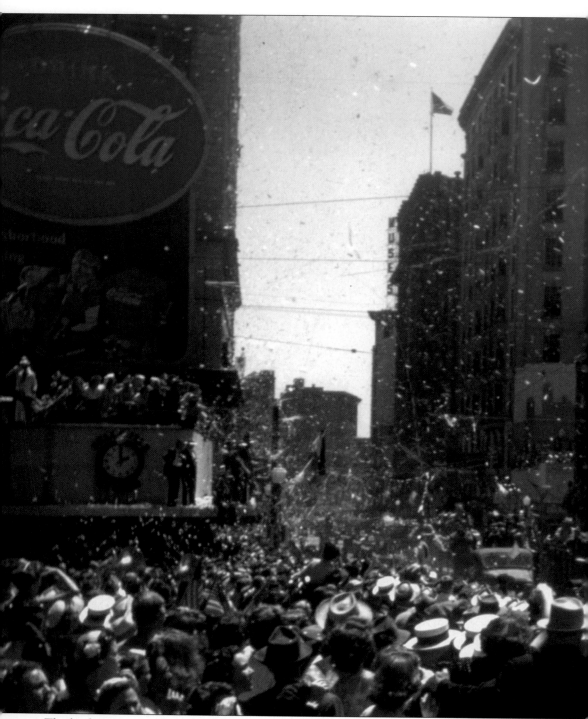

The lead car in a cavalcade featuring Gen. Courtney Hodges and 50 First Army veterans makes its way down Peachtree Street amid an avalanche of ticker tape and confetti. Troops from the First Army were among the lead elements in the Normandy landing and the first into

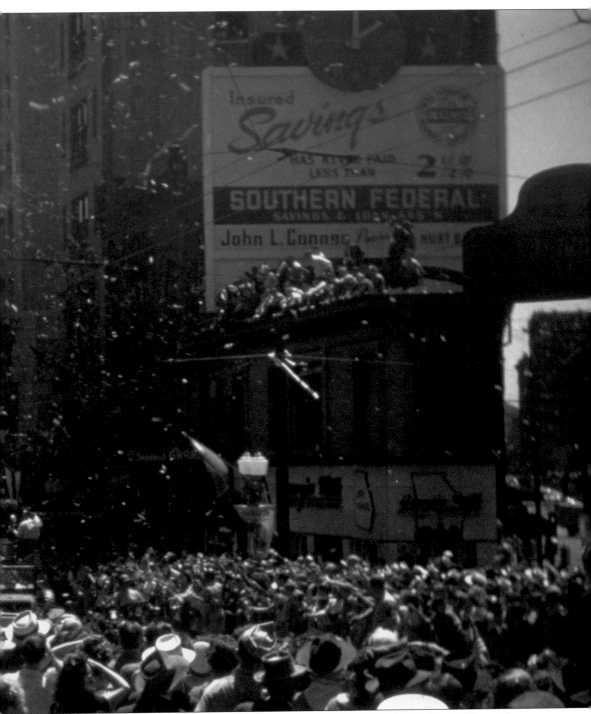

Paris. Thousands of grateful and proud Atlantans turned out to welcome home Georgia's most famous soldier on "Heroes' Day," May 24, 1945. General Hodges was born in Perry, Georgia.

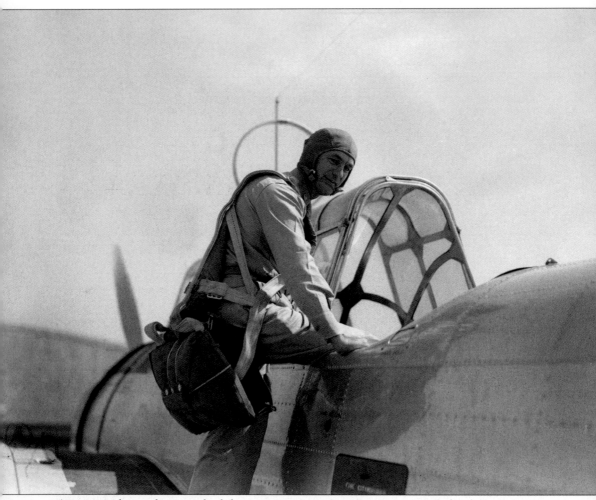

An army pilot is photographed during exercises at Fort Benning near Columbus, Georgia.

Four
GEORGIA'S MILITARY INSTALLATIONS

In Atlanta and throughout Georgia, the United States armed forces maintained an impressive array of training facilities, induction centers, and air bases that played vital roles in securing Allied victory. The Infantry School at Fort Benning and the base at Camp Toccoa trained the officers and paratroopers who landed across enemy lines at Normandy to begin the liberation of France. The air force and navy trained aviators and defended the Atlantic coast at bases located in Atlanta, Brunswick, and Savannah. The Women's Army Corps (WACS) and Women Appointed for Voluntary Emergency Service (WAVES) picked Milledgeville and Fort Oglethorpe as training outposts, and Fort McPherson in Atlanta inducted many new soldiers each day.

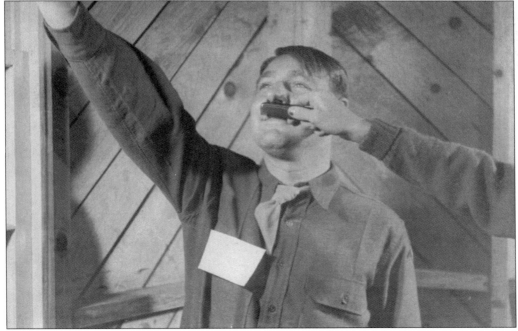

A soldier at Fort McPherson mocks the Nazi leader, Adolf Hitler. The American public and many in the service viewed Hitler both as a vicious tyrant and a buffoon.

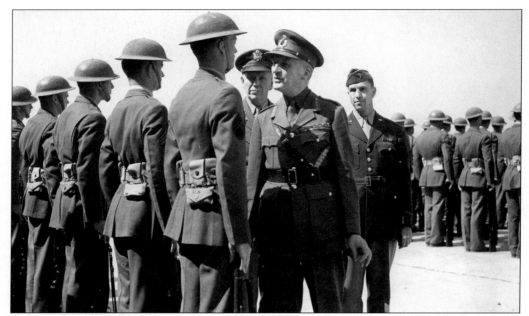

British Field Marshall Sir John Dill questions a member of the 29th Infantry's guard of honor at Lawson Field as Gen. George Marshall, left, and Gen. Levan Allen, Infantry School Commandant, look on. This photograph was taken shortly after the arrival of Dill and Marshall at the Infantry School at Fort Benning in Columbus, Georgia. Marshall was once the head instructor at Benning.

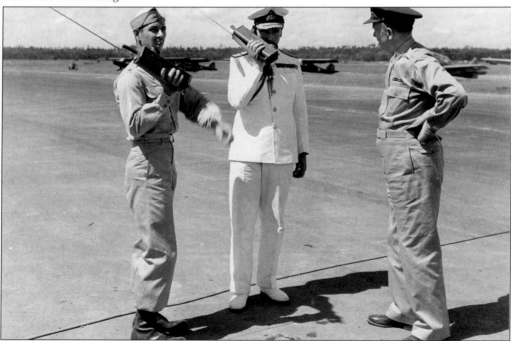

Vice Adm. Lord Louis Mountbatten, Chief of the British Commandos visits Fort Benning during the summer of 1943. General Levan, left, and General Marshall flank Mountbatten.

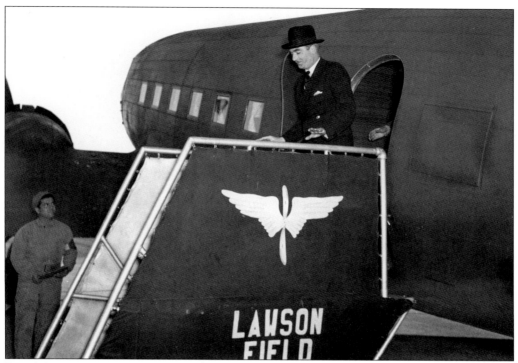

British Foreign Secretary Anthony Eden arrives at Fort Benning to view demonstrations at the Infantry School. The visit was part of a tour of army posts and training centers that the British emissary made with George Marshall and John Dill, pictured below.

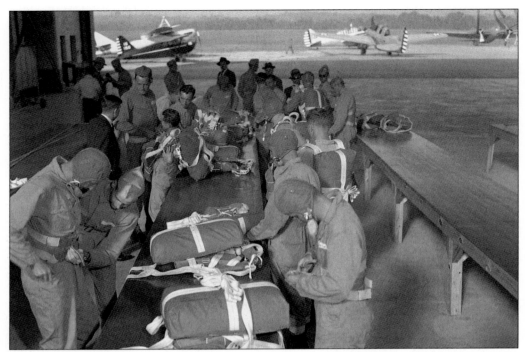

Paratroopers involved in training exercises are pictured at Fort Benning. In response to the Germans' effective use of parachute troops at the start of World War II, the United States Army established a centralized training facility at Fort Benning in May 1942. The Army Parachute School trained all airborne units in this new form of combat.

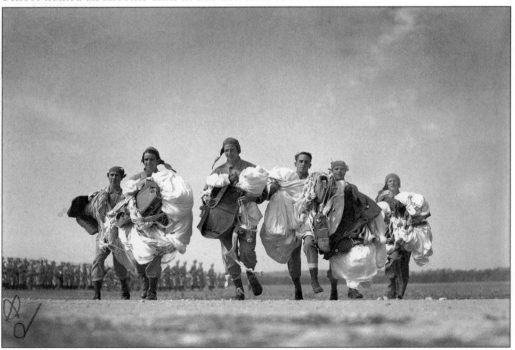

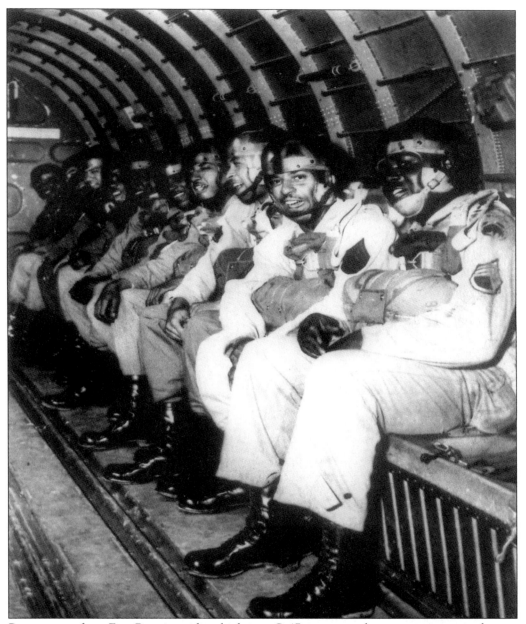

Paratroopers from Fort Benning riding high in a C-47 transport plane, preparing to make one of the required five qualifying jumps to earn their wings. In December 1944, the all-black 555th Parachute Infantry Company, later renamed Company A, 555th Parachute Infantry Battalion, arrived at Fort Benning for training. Despite proving their skills at Fort Benning, the unit never saw combat overseas, but instead were deployed to the Pacific Northwest of the United States, dropping in to fight forest fires caused by Japanese incendiary balloons.

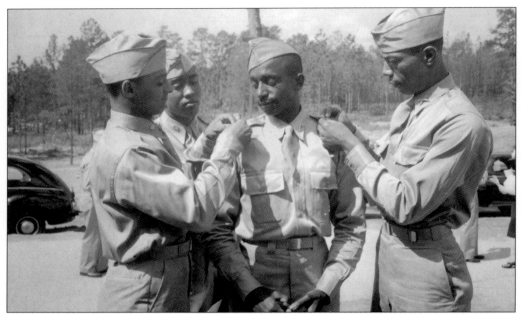

New graduates from Fort Benning's Officer Candidate School pin their brass bars on each other's shoulders. During World War II, the army and air force limited black enlistment to 10 percent of their fighting forces. However, as the war continued, the Army faced a shortage of ground combat troops. Black soldiers who volunteered were permitted to fight in segregated units alongside white combat units.

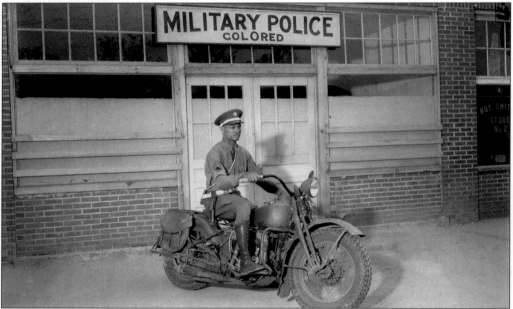

An MP on motorcycle stands ready to answer calls at Fort Benning. Most units in the United States armed forces were segregated throughout World War II and remained so until 1948, when President Harry Truman issued an executive order formally integrating all branches of the military.

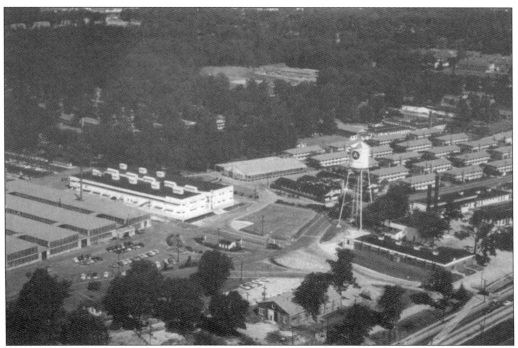

Here is a birds-eye view of Fort McPherson. The base, located four miles from downtown Atlanta, was named in honor of Maj. Gen. James Birdseye McPherson, who was killed on July 22, 1864, during the Battle of Atlanta. During World War II Fort McPherson served as an induction, reception, and separation center, where hundreds of men were processed daily.

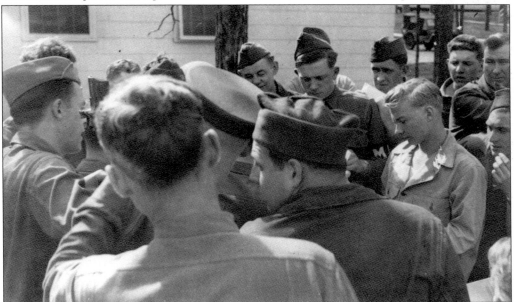

Soldiers at Fort McPherson gather at mail call, eagerly awaiting word from home. Whether stationed on the mainland or serving abroad, nothing was as important to a soldier as getting a letter from a loved one.

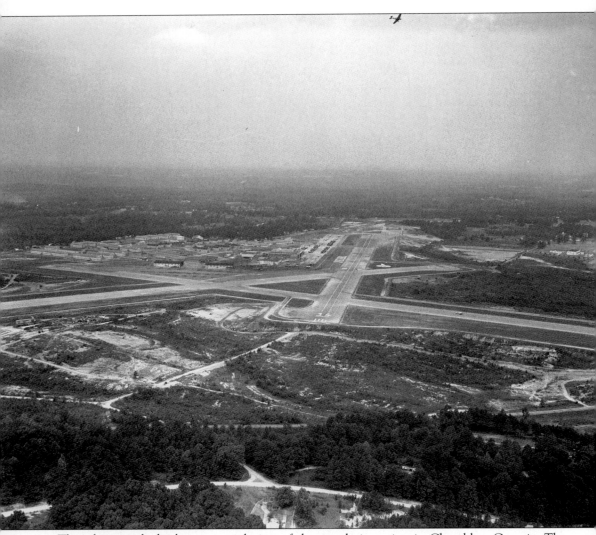

This photograph displays an aerial view of the naval air station in Chamblee, Georgia. The naval reserve aviation base was built on land that had housed Camp Gordon, a temporary army post for training infantry during the First World War. The new base opened on March 22, 1941, to train navy and Marine Corps aviators. The base was officially designated U.S. Naval Air Station Atlanta in January 1943. Today it is the site of DeKalb-Peachtree Airport, a general aviation airport handling corporate jets, charter planes, and helicopters.

Camp Toccoa was established in 1938 as a training camp for the Georgia National Guard. It was named Camp General Robert Toombs in honor of the Confederate general. The name was changed after the war department chose the location for a paratrooper basic training site shortly after World War II was declared.

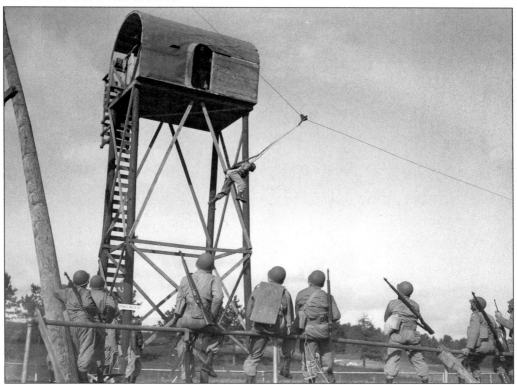

In July 1942, more than 20,000 recruits began arriving at Camp Toccoa to join the 506th Parachute Infantry and three other regiments of the 101st Airborne Division. Many failed to make it through the rigorous training, which included rappelling, nonstop calisthenics, and practice parachute jumps from towers.

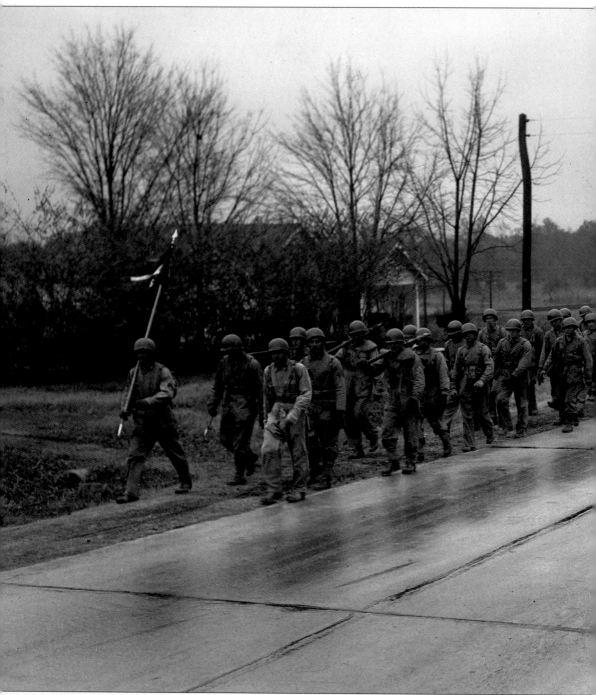

In December 1942, the Easy Company of the Second Battalion of the 506th completed its training at Camp Toccoa with a grueling 115-mile march to Atlanta. Easy Company played a vital role in the Normandy invasion, the most spectacular and most remembered of World War II campaigns, landing behind enemy lines at Utah Beach to begin the liberation of France.

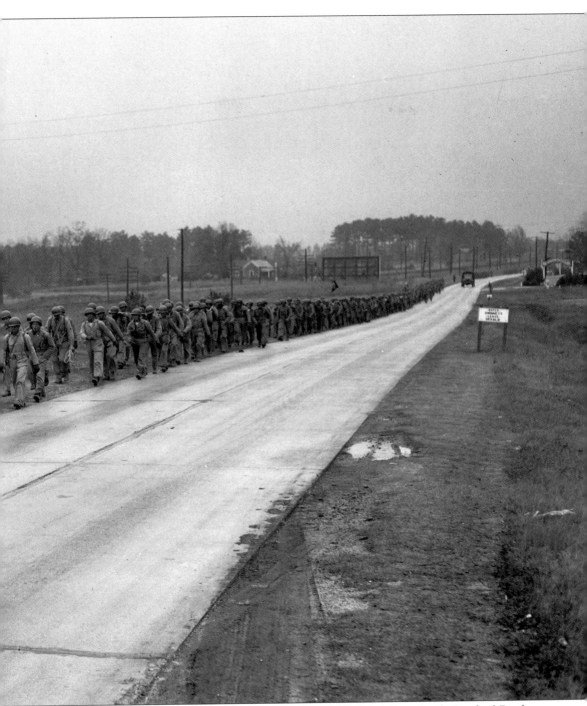

Historian Stephen Ambrose chronicled their story in his bestselling book *Band of Brothers*, which director Steven Spielberg made into a 10-hour epic aired on HBO. Photographs taken during the Atlanta march appear on the following pages.

Troops attend to sore feet during a break in the march.

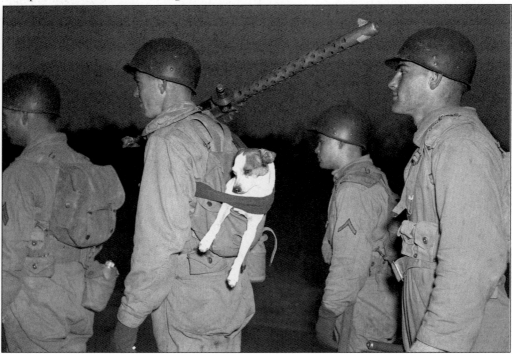

A soldier carries along "Draftee," the company mascot, the only one to ride during the famous march.

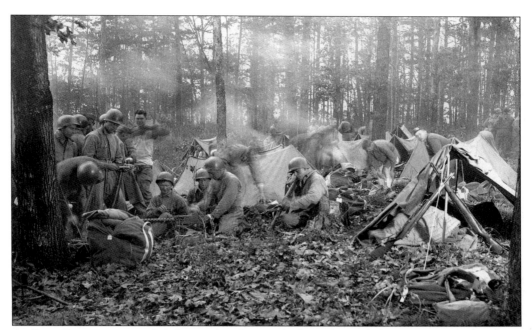

As Easy Company neared Atlanta, they bivouacked on the Oglethorpe University campus, unloading full field packs, rifles, and machine guns.

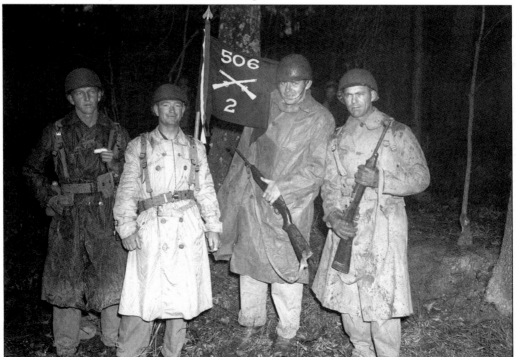

Officers of the 506th posing for the camera on the last stretch of the march (from left to right) are Lt. S.H. Mathieson of Los Angeles; Maj. Robert L. Strayer of Philadelphia, commander of the battalion; Capt. W.J. Boyle of Brooklyn; and Lt. J.K. Davis of Oklahoma City.

A B-24 Liberator arrives from Europe at Hunter Field in Savannah. Hunter Field was the first stop in the United States for bombers on their way from Europe to the Pacific theater during the last months of the war.

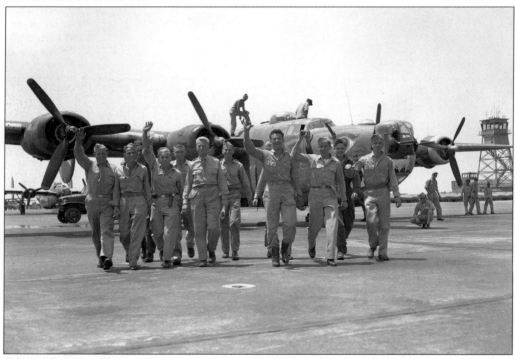

After debriefing, these men were flown to Charleston, South Carolina and granted short furloughs at home before flight training for the Pacific theater.

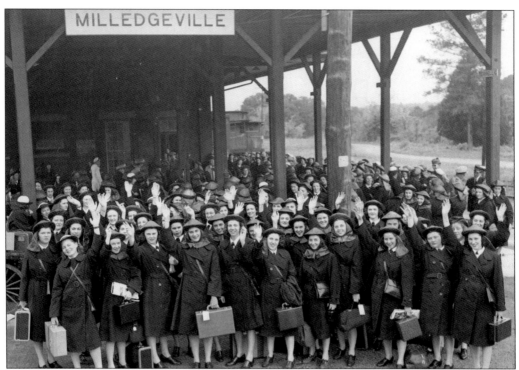

Graduates and cadets of the Naval Training School for WAVES (Women Appointed for Voluntary Emergency Service) bid farewell to each other at the Milledgeville train depot. Georgia State College for Women (now Georgia College and State University) in Milledgeville was one of four colleges in the United States chosen to accommodate the WAVES program. After three months of intensive instruction, the cadets were assigned jobs at naval stations.

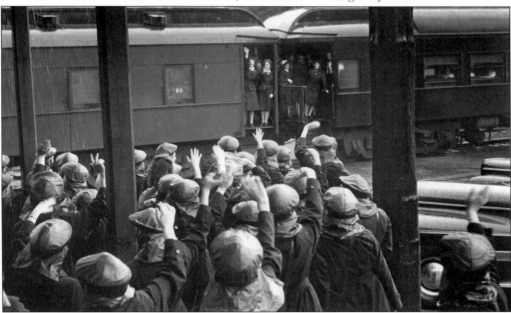

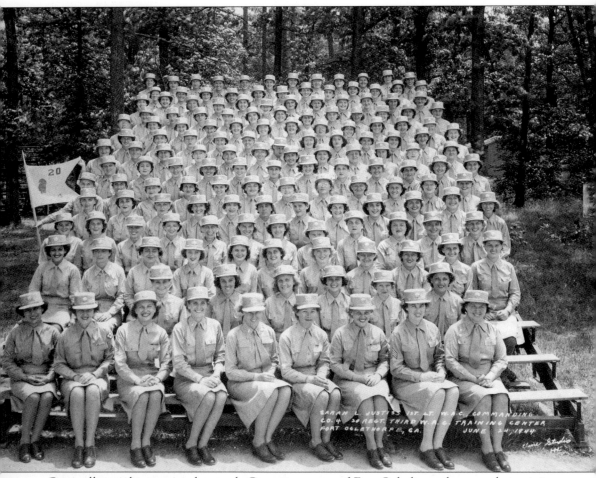

Originally a calvary post, the north Georgia outpost of Fort Oglethorpe became the training center for the Third Army Corps in 1943. The WAC center closed in 1945, and Fort Oglethorpe became a redistribution center for out-processing returning GIs. This photograph depicts Company Four of the Twentieth Regiment.

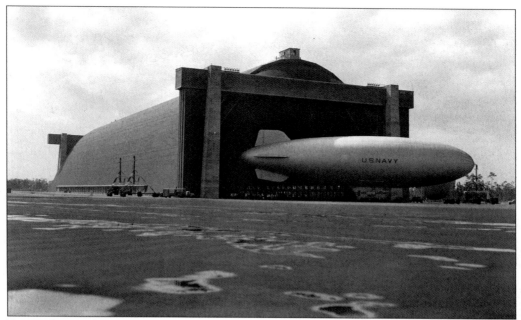

Responding to the threat posed by German U-boats off the Atlantic coast, the Navy established Glynco Base in Brunswick. Blimps from Glynco Base, the largest blimp base in the world, safely escorted thousands of ships without a single vessel lost to enemy submarines. Today, Glynco houses the Federal Law Enforcement Training Center.

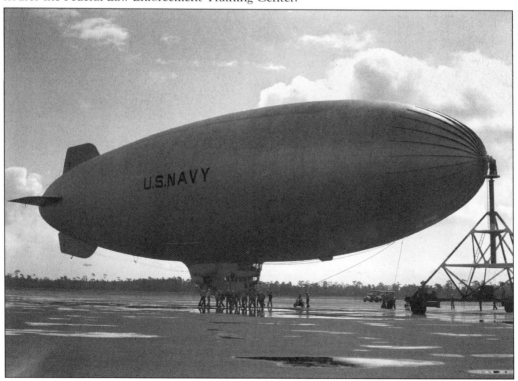

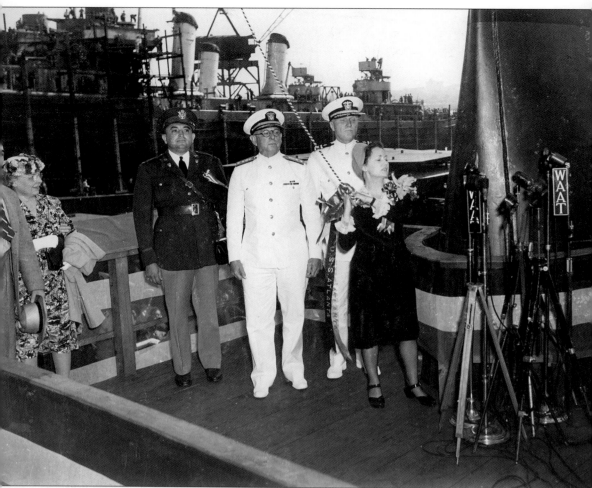

With a champagne bottle in hand, Margaret "Peggy" Mitchell strikes a pose during one of many rehearsals for the gaggle of newsreel and newspaper photographers at the USS *Atlanta*. Mitchell was on hand at the Federal Shipbuilding and Drydocks in Kearny, New Jersey to christen the sleek cruiser bearing the name of her hometown.

Five

"I Christen Thee . . ."

Atlanta and Georgia had a number of connections to the United States's naval effort during the war. The navy used the name Atlanta for two light cruisers that battled the Japanese in the Pacific— Atlanta III and Atlanta IV. Several Liberty ships, which were cargo vessels manned by merchant seamen and a naval armed guard, were named after some of Atlanta's most notable historical figures. The SS Clark Howell, Henry Grady, and Hoke Smith were christened and commissioned during the navy's massive shipbuilding campaign in the coastal city of Brunswick, Georgia, which produced over 100 Liberty ships.

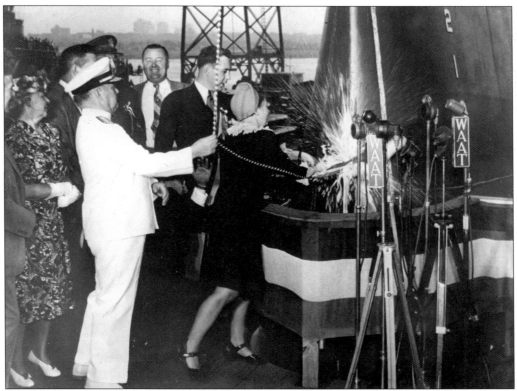

With a hefty two-handed swing and a bubbly spray, the author of *Gone with the Wind* propels the navy's newest light cruiser into service.

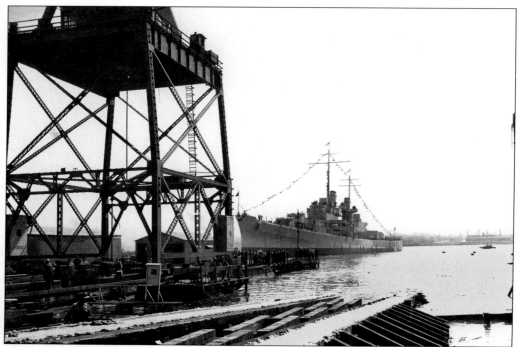

Atlanta (CL-51) glides majestically into the New Jersey waters. Commissioned on December 24, 1941, the ship spent the next four months along the Atlantic coast before leaving for the Pacific theater in early April 1942. It was the third launching of a warship named *Atlanta* in the United States. The first *Atlanta* was an ironclad ram built by the Confederate navy. The second *Atlanta* was a protected cruiser launched in 1884.

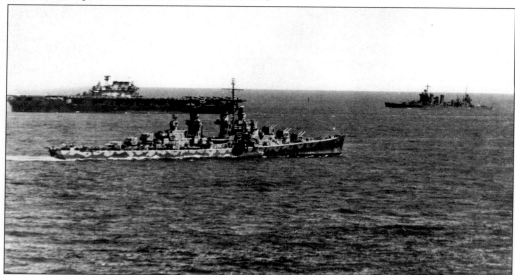

Shortly after deployment in the South Pacific, *Atlanta* (CL-51) joined a task force around the aircraft carriers *Enterprise* and *Hornet*. This photograph shows the *Atlanta* (foreground) during the Battle of Midway in 1942. The first combat for the *Atlanta* came two months later in the Solomon Islands.

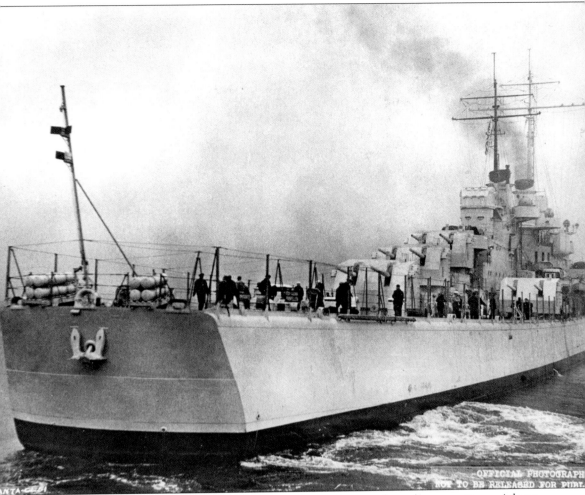

Off Guadalcanal Island, in one of the war's most harrowing naval combat operations, *Atlanta* drove Japanese airplanes away from a United States airfield only to suffer major damage from both enemy and "friendly" fire. It was sunk on the order of Capt. Samuel P. Jenkins after the remainder of the crew had been removed. There were 172 deaths and 79 men wounded. The ship was awarded the Presidential Unit Citation, the only light cruiser to attain that award during World War II.

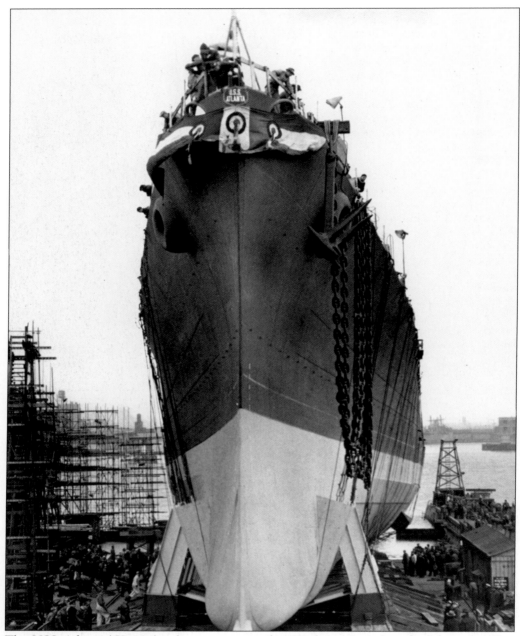

The USS *Atlanta* (CL-104)—the successor to the "Mighty A"—is launched from the New Jersey shipyards in February 1944. Six-hundred feet in length and with a much larger displacement than *Atlanta* (CL-51), it was equipped with five- and six-inch guns.

Atlanta's most famous author again served as sponsor for the fourth in a proud line of fighting ships. Shortly before the christening of *Atlanta* (CL-104), Margaret Mitchell posed with Brig. Gen. Clark Howell, publisher of the *Atlanta Constitution* (left) and George Biggers, vice president and general manager of the *Atlanta Journal* (right).

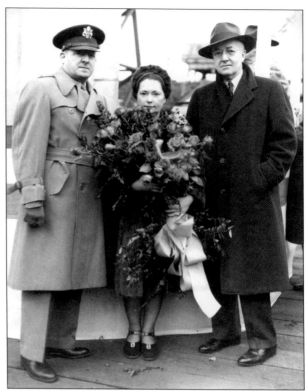

Servicemen and dignitaries gather on the deck of USS *Atlanta* (CL-104) for commission ceremonies at the Philadelphia Naval Yard in December 1944. The ship and its crew also served in the Pacific, this time defending aircraft carriers near Okinawa and targets in the Japanese home islands. After the war the ship went through a number of conversions and modifications until 1970, when the former light cruiser was finally sunk during an explosives test as a target ship off San Clemente Island, California.

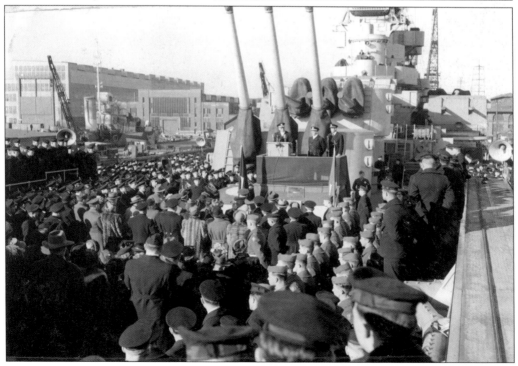

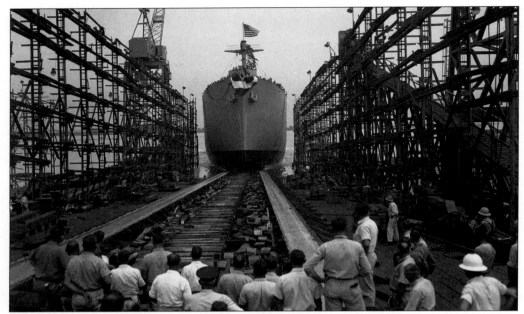

The launching of the Liberty ship *Hoke Smith* took place on September 16, 1943, at the Southeastern Shipbuilding Corporation in Savannah, Georgia. Liberty ships were cargo vessels designed for the lend-lease program for Great Britain before the United States entered World War II. The original plan was to build 60 such ships, but production accelerated after the Japanese attack at Pearl Harbor and German U-boat success in the Atlantic. Over 2,700 Liberty Ships were built by the end of the war.

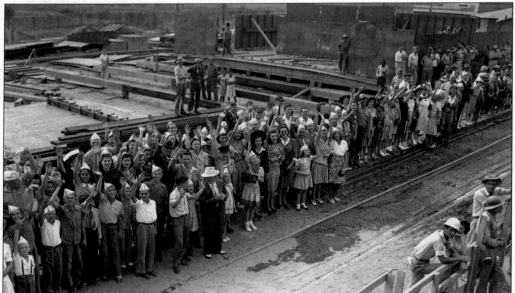

Members of the Georgia 4-H Club wave to the crew of the *Hoke Smith* as it makes its way toward the Savannah River. Named after the former Georgia governor and senator, the *Hoke Smith* was the first of five Liberty ships built with $9.5 million in bonds sold by Georgia 4-H Club members.

Pageantry and patriotism are on display as the Liberty ship *Clark Howell* stands ready for its launch at the Savannah yards. The standard Liberty ship displaced approximately 7,000 tons and could carry the equivalent of 80 freight cars of food, guns, armor, and planes to Allied positions. This vessel was the 44th Liberty ship produced by the Southeastern Shipbuilding Corporation, which would eventually build close to 90 of the Atlantic cargo-carriers during hostilities with the Axis powers.

Harriett Howell, the widow of the deceased editor of the *Atlanta Constitution*, does the honors as the SS *Clark Howell* is christened. Atlanta Mayor William B. Hartsfield *(left)* is an amused onlooker to the light-hearted ceremony.

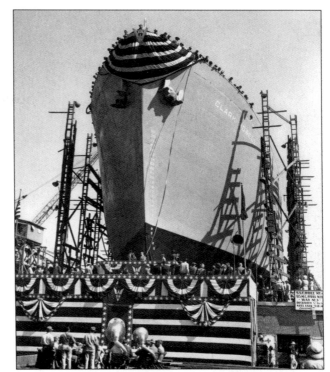

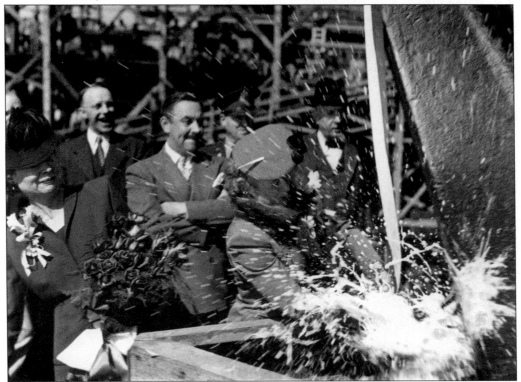

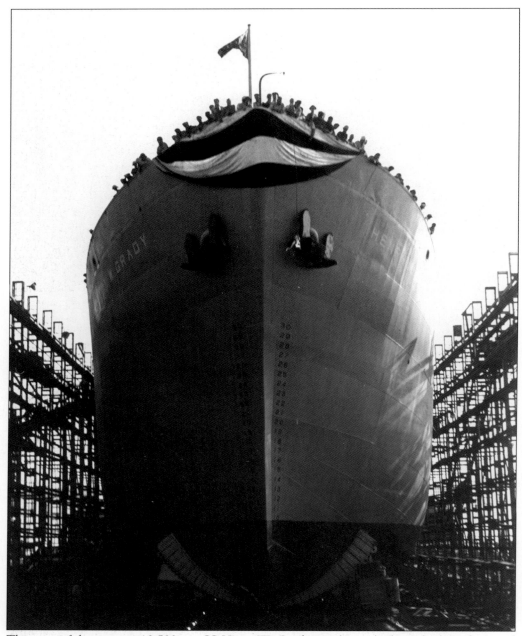

The crew of the massive 10,500-ton SS *Henry W. Grady* stands overlooking the launching pad at the James A. Jones Construction Company in Brunswick, Georgia, as the newest of America's Liberty ships slowly sets out to sea. The ship, named after the famed Atlanta newspaper editor and New South booster, was outfitted in October 1943 and was used by the navy for 27 years.

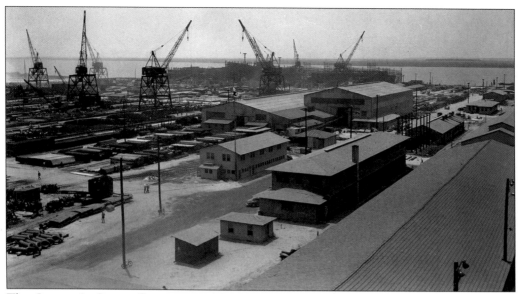

The James A. Jones Construction Corporation operated this shipyard on Brunswick's waterfront to produce Liberty ships for the United States Merchant Marines. Over 16,000 skilled workers around the clock produced at least 4 vessels a month from 1942 to 1944. Always humming with activity, the 4,500-acre complex was an important part of America's incredible war-production effort. When this photograph was taken in May 1943 the United States was churning out over 150 merchant vessels a month.

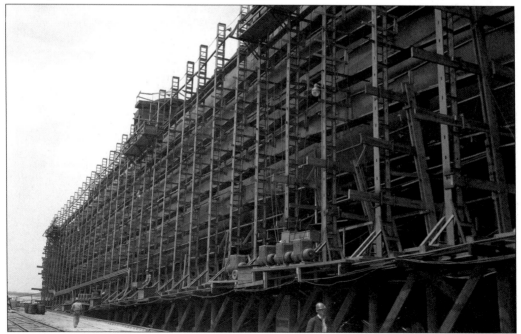

A nearly completed ship is barely visible through the grid of scaffolding along the launching ways. Shipbuilders walking beside this huge vessel give perspective to the size of these massive crafts that were produced so quickly for the Allied effort. This is the SS *Thomas Todd*.

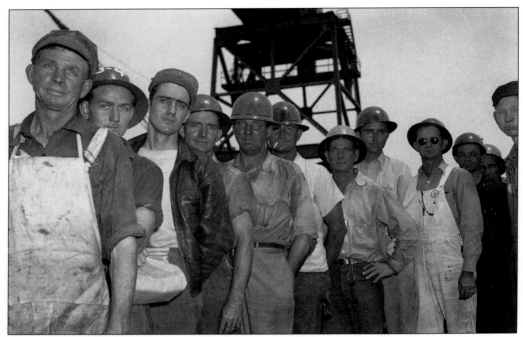

The majority of Brunswick shipyard workers were Georgians. Most were farmers from rural areas, but many Atlantans went south in search of employment. The influx of new residents tripled the population of Brunswick from a pre-war level of 13,000 to over 40,000 by 1943.

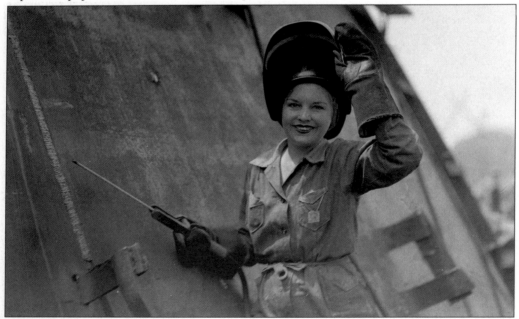

A photographer has persuaded Emma Elizabeth McKinnon from Waycross to remove her welder's mask and mug for the camera. Spurred on by higher wages and posters featuring "Rosie the Riveter," Georgia women found opportunities in war production facilities throughout the state. More than six million women became employed in war industries nationwide.

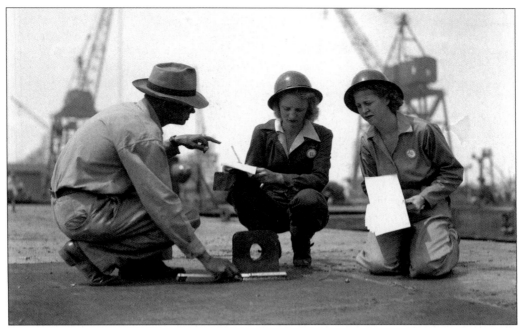

Mary Morgan (left) of Atlanta and Pearl Durham of Dalton work as welder-checkers at the Brunswick shipyards. Morgan moved from her parent's home in Atlanta, leaving two small children. At the time this photo was taken, her husband had been captured and held as a prisoner-of-war in Italy.

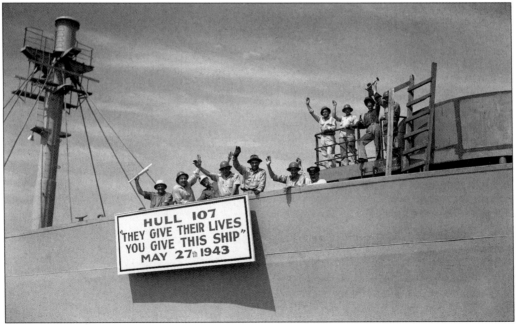

A sign captures the spirit of the Brunswick shipbuilders who felt the importance of their job and the connection they felt with those overseas. The date on the sign refers to a production deadline for a particular vessel.

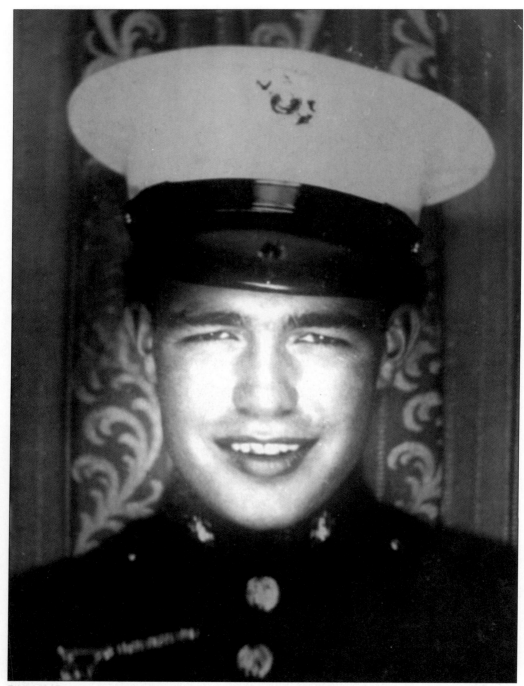

Born in Georgia in 1922, Frank Power Jr. enlisted in the Marine Corps in June 1941. He was killed when the battleship *Arizona* was sunk at Pearl Harbor. His mother states that when 19-year-old Frank left home, he said, "You know I have made a success in my school work and in the newspaper business. I am going to make you still prouder of me by helping defend our country so it will continue to be the most desirable place in the world to live."

Six
THE VETERANS

The story of Atlanta's contribution to the war effort would not be complete without featuring area individuals who served their country. This chapter contains the names, stories, and photographs of just a few of those men and women. Atlantans from a wide variety of social and economic backgrounds served in all four branches of the armed services. Sailors lost their lives at Pearl Harbor, women flew planes between bases in the United States, and soldiers helped liberate "death camps" in Europe. From Georgia's Fort Benning to North Africa, from France to Guadalcanal, Atlantans in the armed forces helped to ensure Allied victory.

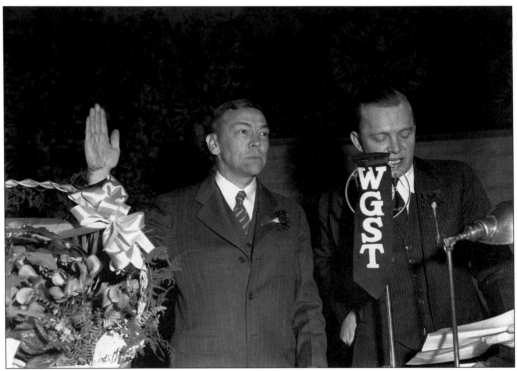

Pictured is the swearing-in ceremony of Atlanta mayor Roy LeCraw, who defeated incumbent mayor William B. Hartsfield by a razor-thin margin in 1940 to become Atlanta's 44th mayor. Shortly after the United States entered World War II, LeCraw, a major in the Georgia National Guard, resigned his elective office to serve overseas as a member of General Eisenhower's staff.

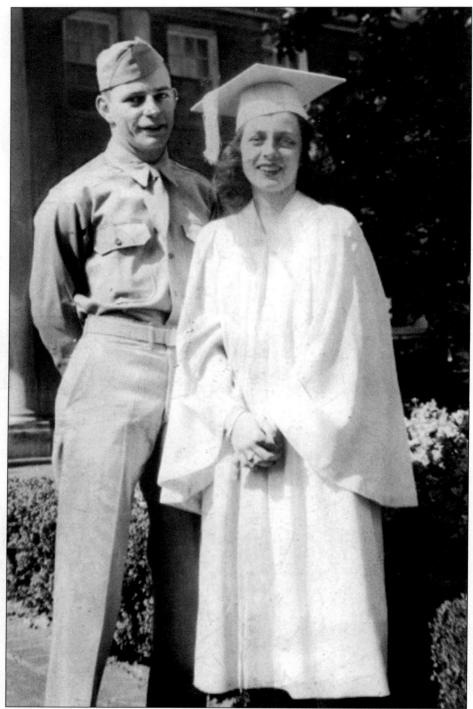

Ernest Beaudry, a native Atlantan, shown here with his sister Helen, lost his life in combat near Aachen, Germany. He joined the army at age 21 in May 1944 and was killed just six months later. His father founded Beaudry Ford, a leading Atlanta automobile dealership.

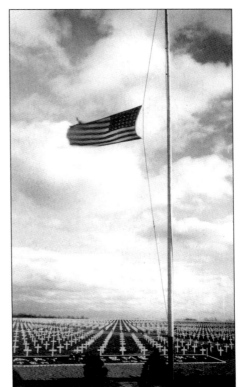

Ernest Beaudry was buried here in the American Military Cemetery, one of 19,000 Americans, including 20 Atlantans. Dutch families, grateful for their liberation, adopted specific graves and regularly placed flowers on them to show their appreciation. In the cemetery, flowers were planted spelling out "May They Rest in Peace" in English and nearby "Out of Deep Gratitude" in Dutch.

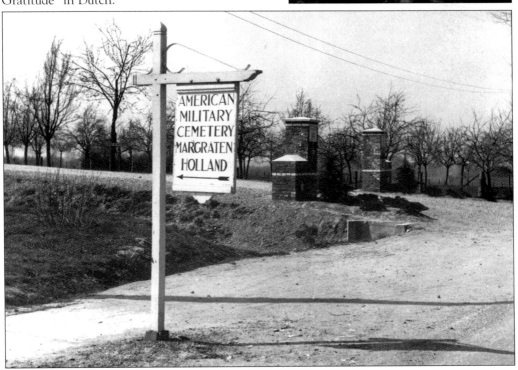

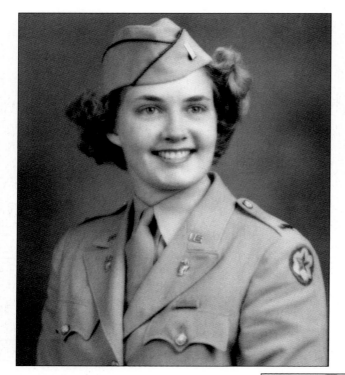

Edith Wilson Harber was a graduate of the Georgia State College for Women (now Georgia State University) and served as an officer in the Women's Army Corps. During World War II she was stationed in Missouri, where she learned to fly small aircraft. She continued her flight training after the war in Atlanta.

Waiting for Edith Harber in Atlanta was her future husband, Earl P. Cook. Cook grew up in LaGrange, Georgia, and entered the Signal Corps in 1941. He served in New Caledonia, Guadalcanal, Fiji, and the Philippines. He was awarded the Bronze Star and the Presidential Unit Citation and held the rank of major in the Officers' Reserve Corps. After the war, he returned home, received an electrical engineering degree at Georgia Tech and married Edith Harber.

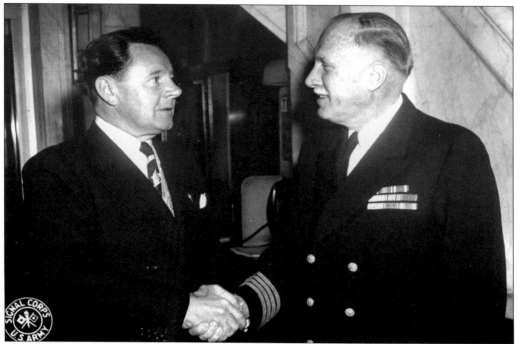

One of Atlanta's leading citizens, real estate executive and city alderman, Jesse Draper (right) shakes hands with Secretary of the Navy J.L. Sullivan. After serving as lieutenant in the North Sea Fleet during World War I, Draper returned to Atlanta to pursue his business interests. In May 1941, he resumed active duty.

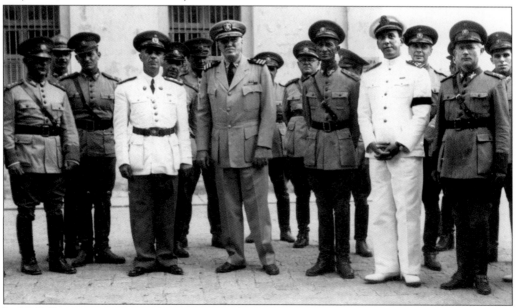

In 1942 Draper was promoted to captain and appointed as commanding officer of the American naval facilities in Brazil. Commander Draper, center, is flanked by officers of the Ninth Regiment of the Infantry of Pelotas.

Atlantan Virginia Broome Waterer was one of thousands of female air force pilots in World War II. A shortage of experienced pilots pushed the government to launch an experimental program to train women pilots to fly military aircraft. WASPs (Women Air Force Service Pilots), as they were known, ferried planes to military bases in the United States.

Virginia Broome's squadron poses in front of a B-17 aircraft at Lockborne Air Base in Columbus, Ohio, a WASP training facility. The WASP program was deactivated in 1944 without attaining military status. In 1979, the WASPs were granted military recognition and veteran status.

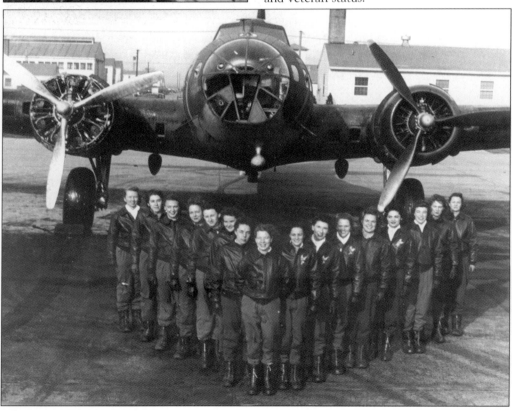

Lt. Elizabeth Setze, the first woman officer sent from Atlanta to the naval training school for WAVES at Smith College in Massachusetts. She enlisted in the WAVES on August 1, 1941, and was detached from duty in April 1947.

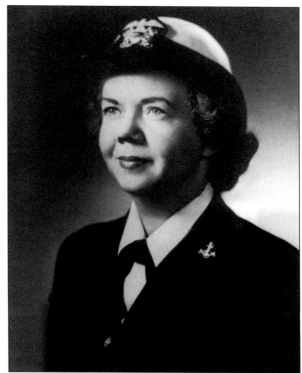

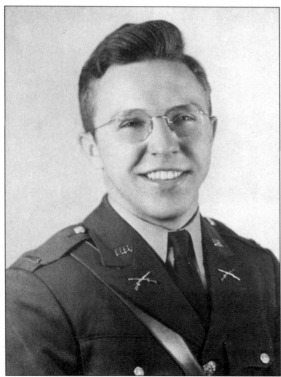

Lt. Eldridge Brown was killed in action in Tunisia in January 1943. Posthumously, he was awarded the Croix de Guerre and the Purple Heart. Born in Atlanta in 1920, he attended Boys High School and then graduated summa cum laude from Davidson College in North Carolina. While at Davidson, he was a captain in the Reserve Officers' Training Corps (ROTC), a letter-winner in cross country track, and a member of Phi Beta Kappa.

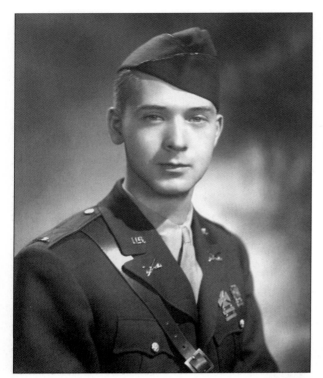

Pictured is James Ranson Haverty, the grandson of the founder of Atlanta's Haverty Furniture. Known to his family as Ranson, he entered active service in 1942 and eventually attained the rank of major. His performance in the battlefield earned him the Bronze Star. Ranson returned home to Atlanta in 1946 and became president of the family business in 1955.

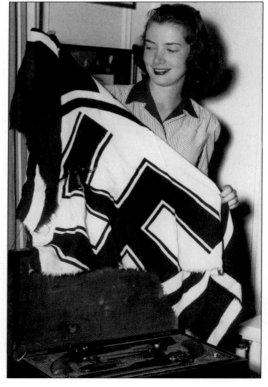

A Nazi flag and pistol set were souvenirs sent home by Ranson Haverty to his sister, Betty. In one of his letters home, he wrote, "I was able to see one of the 'Death Camps' that are turning up," referring to camps of political prisoners from Eastern European countries.

Ralph Hollis, a member of the U.S. Naval Reserve for seven years before the war, was called to active service in May 1941. He served as a communication officer aboard the battleship USS *Arizona* and was killed in the Japanese attack on Pearl Harbor. He was born in Crawfordsville, Georgia, and went to high school in Mansfield. He was married and the father of two children.

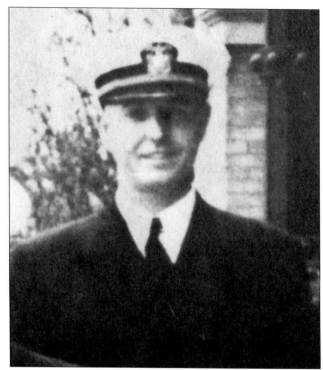

Hugh Harris Ramsour was born in Cobb County, Georgia, in 1905. He died in 1942 at age 37 while serving on an oil tanker bound from Glasgow, Scotland, to New York. Before World War II, he served in the U.S. Navy and Merchant Marines. Afterward, he served four years with the Atlanta police department and seven years as a detective in New York. He rejoined the merchant marine in May 1942 and lost his life six months later.

Jane Meade LeRoux was a volunteer for the American Red Cross in Europe, North Africa, and Italy. During the war she opened and operated clubs that entertained troops on leave. While working in a club in Algeria, LeRoux produced and acted in a popular play, *How Green Was Our Corn* (a photograph of the cast appears below), which garnered much attention from the soldiers, so much that General Eisenhower requested a special showing.

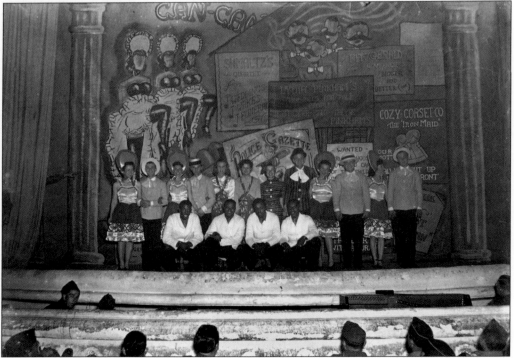

Born in Atlanta in 1924, Walter Ellis joined the navy in June 1941 and was killed at the Battle of Santa Cruz near Guadalcanal in October 1942. He was a ship's cook third class serving aboard the USS *Hornet,* an aircraft carrier. In a letter to Ellis's parents, his commanding officer praised "his bravery under fire" (many cooks were assigned to battle stations during combat). "His ability would have soon earned him a promotion in rating."

Maj. William L. Funkhouser was chief of operative dentistry of the 43rd General Hospital. The 43rd was first organized in June 1917 at Emory University in Atlanta. During World War II the unit was reactivated at Camp Livingston, Louisiana, and stationed overseas in North Africa, Italy, and France. The hospital treated over 16,000 patients. Photographs from Funkhouser during his tour of duty appear on the next page.

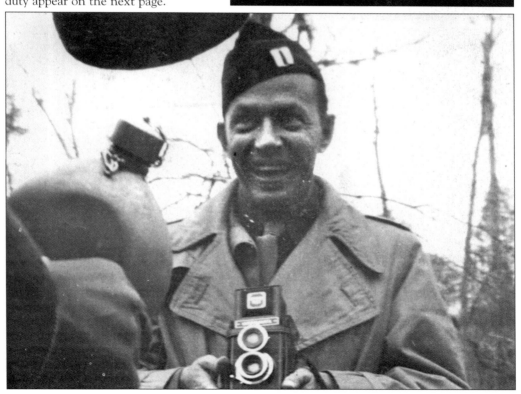

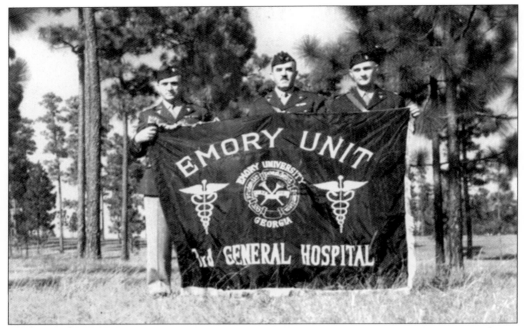

The above photograph captures the presentation of the 43rd General Hospital Banner at Camp Livingston. Pictured (from left to right) are the following: Lt. Col. Ira Ferguson, Col. Leroy D. Soper, and Lt. Col. Richard H. Wood, Chief of Medical Service.

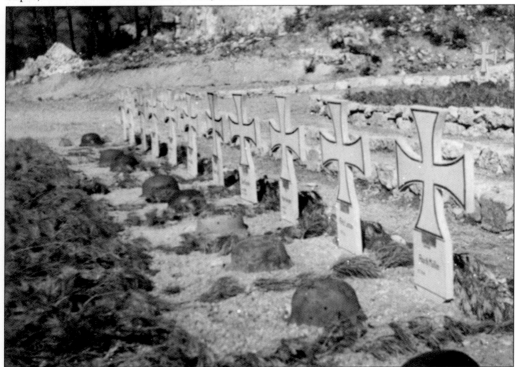

Pictured is the German cemetery behind the 43rd hospital in France.

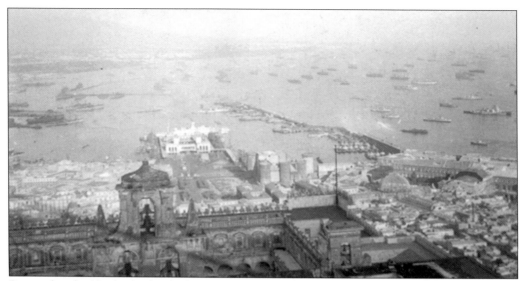

Pictured is the Naples harbor before the invasion of southern France.

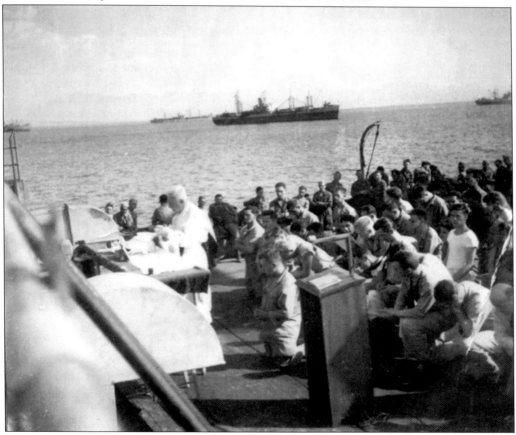

Religious services are held for the 43rd aboard a navy personnel carrier prior to the invasion of southern France in August 1944.

John Guinn Smith (center) of Dalton poses with friends in front of a monument in Japan. Smith served as a mechanic in an engineering unit in Fukuoka, Japan, after the war. His unit was responsible for rebuilding the area. Smith attempted to enter the army early in the war but did not weigh enough to be accepted. Undaunted, he gained weight and successfully enlisted in 1945.

Crowds of Japanese civilians looking for work in rebuilding their city. Smith said they would wait all day outside for any opportunity.

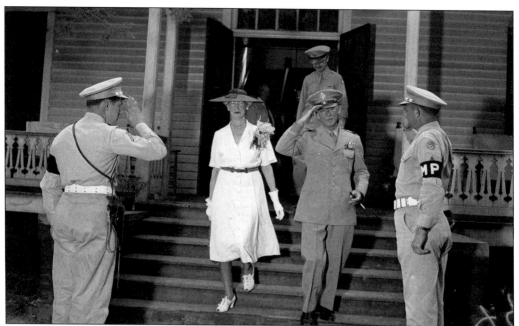

Gen. Courtney Hicks Hodges, commander of the First Army and a native of Perry, Georgia, arrives for a hero's welcome in his hometown after the Allied victory in Europe. Hodges's military career began in 1906 and lasted 43 years. He was promoted to lieutenant general in 1943 and named commander of the Third Army. In 1944, he became deputy to Gen. Omar Bradley, commander of the First Army. After the Normandy invasion, Hodges succeeded Bradley as commander of the First Army. He was the highest-ranking Georgian in the United States armed forces during World War II.

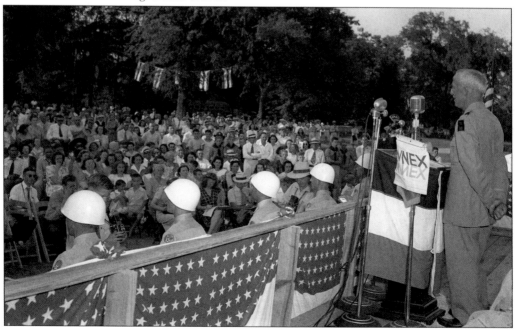

Veterans returned en masse at the end of the war, ready to resume their lives at home. Here is Corporal Richard Gamble of Roslindale, Mississippi, awaiting demobilization at Fort McPherson in Atlanta.

Seven

ATLANTA
A CITY TRANSFORMED

World War II officially ended on V-J Day, August 15, 1945, but Atlanta still reflects the war's legacy today. The war forever altered the economic and political landscape of the city, ushering in an era of Civil Rights activism, business growth, suburbanization, and transportation development.

World War II produced an economic explosion that ended the Great Depression and created broad-based opportunities for industrial expansion in Atlanta and its suburbs. Building upon the initiatives of the New Deal, Atlanta enhanced its infrastructure with multilane highways and expansion of the airport. Hundreds of new businesses came to the metropolitan area. In the years following the war, Atlanta tripled its geographical size and added tens of thousands of new voters and taxpayers through referendums on annexation.

Included in that growth was an expanding African-American population, emboldened by the wartime experience and ready to assert rights as full citizens. Black entrepreneurs developed neighborhoods for returning veterans. Civic organizations like the Atlanta Urban League fought for better housing and improved health care, while other groups pressed local leaders by registering voters in massive numbers.

With this surge in African-American political and economic activity, however, came racial conflict. Terrorist organizations such as the Ku Klux Klan and the Columbians reemerged, and a new wave of violence spread across Atlanta and the state. Meanwhile, in the governor's race, James V. Carmichael, a racial moderate, lost to ex-Governor Eugene Talmadge, well known for his defense of white supremacy. When Talmadge died before he could take office, the infamous "Three Governors" controversy ensued, finally resulting in Talmadge's son, Herman, winning a special election. The younger Talmadge followed in his father's footsteps on racial matters. With violence on the one hand and racist demagoguery on the other, African Americans and some whites responded with an intensified activism that became known as the Civil Rights movement. The fight against Nazism and fascism abroad contrasted with racial inequality at home inspired many to force America to live up to its democratic ideals, resulting in one of the most profound legacies of World War II.

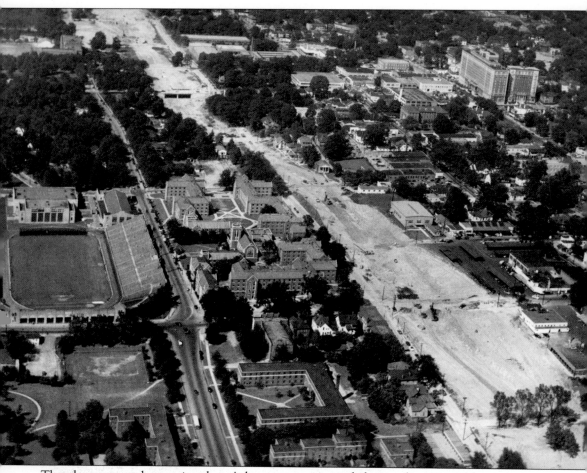

The shortages and austerity that Atlantans experienced during the war soon gave way to economic growth and expansion. To capitalize on this development, the state of Georgia initiated a massive highway construction program that included, among other things, a north-south expressway through downtown Atlanta. This aerial shows the early construction of the downtown connector, where the southbound lanes of Interstate 75 and Interstate 85 meet. At left is the Georgia Tech campus. During World War II, General Eisenhower was struck by the ease of travel on German autobahns. As president, he believed multi-lane highways were critical to a strong national defense. In 1956, Eisenhower signed the Federal Aid Highway Act that provided most of the funds necessary to finish three major interstate highways around Atlanta (I-75, I-85, and I-20), along with Interstate 285, an outer-ring expressway that encircled the city and connected the major transportation routes.

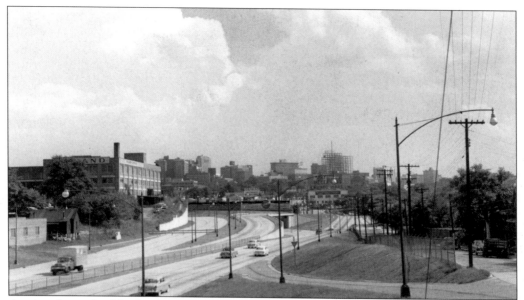

A view from the North Avenue Bridge shows the completed downtown connector. This portion of I-75/I-85 was widened from six to ten lanes in 1989 to accommodate the massive growth of the Atlanta metropolitan area, particularly in the northern suburbs.

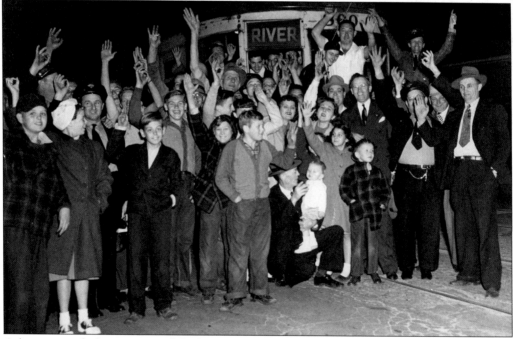

Atlantans mark the occasion of the last streetcar ride in the city in the late 1940s. For decades, the transportation system in Atlanta was dominated by the use of trolleys to carry passengers from the suburbs into downtown on rail tracks. This system was largely replaced by motor buses and the automobile in the 1940s. Atlanta led the way among southern cities in developing a modern transit system after the war.

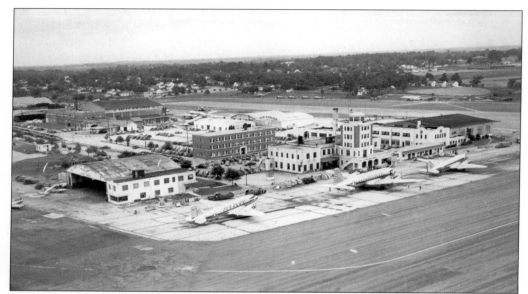

Delta Air Lines passenger planes line up single file in front of the newly constructed terminal at the Atlanta Municipal Airport. During World War II, the army leased property from the city to construct buildings and runways for their operations. The land was deeded back to the city after the war, enabling airport expansion in 1948.

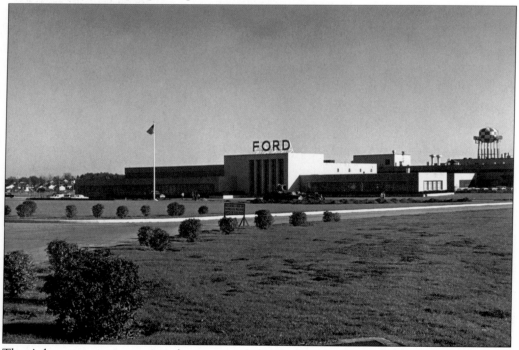

The Atlanta postwar economic boom extended into the suburbs. Fueled by heavy industry, a number of suburban "boom towns" were created beginning in the late 1940s. The Ford Motor Company sold its plant in Atlanta to the War Assets Administration during the war and in 1947 built a $7 million plant south of the city in Hapeville.

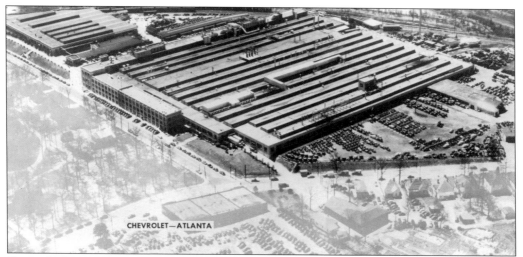

CHEVROLET—ATLANTA

General Motors, which also saw its Atlanta plant turned over to military production during the war, built its multimillion dollar plant in the northern suburb of Doraville. State and federal funds were secured to build Peachtree Industrial Boulevard, a four-lane highway that enabled GM to transport cars and allowed workers easy access to the plant. Businesses flourished along this route, providing further economic growth in the area.

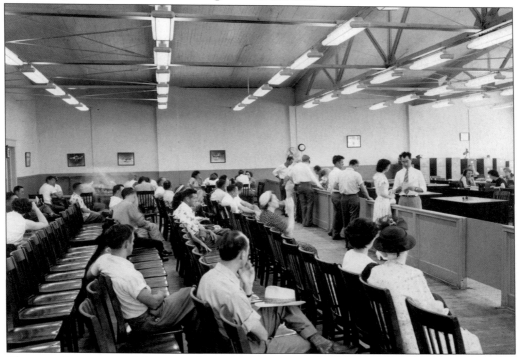

These applicants at an Atlanta employment office awaited interviews for jobs at the former Bell Bomber plant. Bell Aircraft ceased its B-29 operations in 1946 but reopened five years later when the Lockheed Company bought the plant. The presence of Lockheed-Georgia (later Lockheed Martin) continued to trigger phenomenal growth in Marietta and Cobb County for decades afterward.

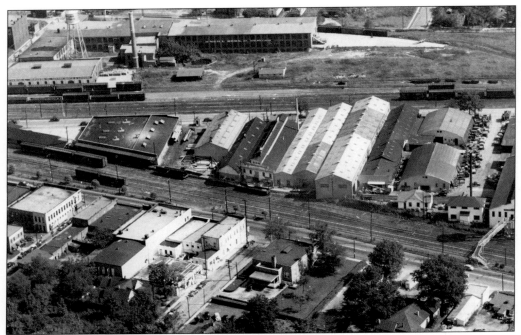

The photograph captures an aerial view of the downtown business and industrial district of the city of East Point, southwest of Atlanta. The town was a hub of industrial expansion in the 1940s and 1950s as dozens of companies invested more than $30 million in capital.

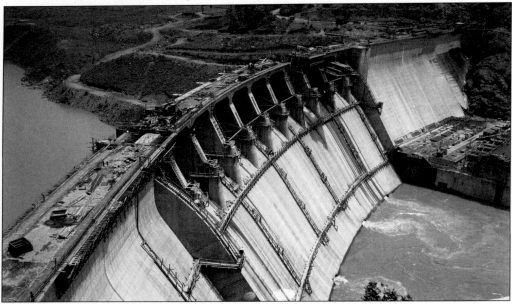

Federal legislation in the 1940s authorized construction of the Allatoona Dam and later the Buford Dam. Both structures are key components of the Chattahoochee River basin and provide power, flood control, navigation, recreation, and water supply to the Atlanta metropolitan region. This photograph was probably taken in 1949 and depicts the latter stages of construction of the Allatoona Dam.

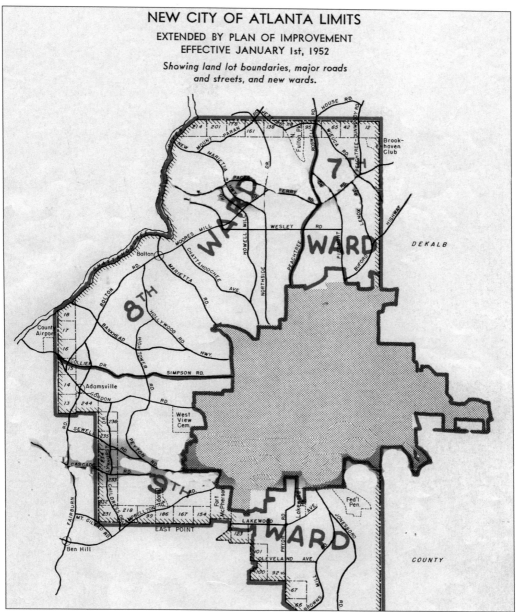

NEW CITY OF ATLANTA LIMITS

EXTENDED BY PLAN OF IMPROVEMENT
EFFECTIVE JANUARY 1st, 1952

*Showing land lot boundaries, major roads
and streets, and new wards.*

Atlanta's political leaders sought to harness economic growth through an annexation plan that would alleviate inefficiencies of parallel services in city and county governments and add 100,000 new residents. The Plan of Improvement increased Atlanta's size from 37 to 118 square miles. The shaded portion of this map marks the city's boundaries prior to the plans' approval by voters and the state legislature. White residents inhabited much of the annexed area and this became another reason for the Plan of Improvement. To keep Atlanta a majority white city, Mayor Hartsfield and other civic and political leaders urged the annexation of the affluent Buckhead and Druid Hills sections. Atlanta's postwar leadership was faced with a growing African-American population in the city limits and increasing pressures to recognize them politically.

115

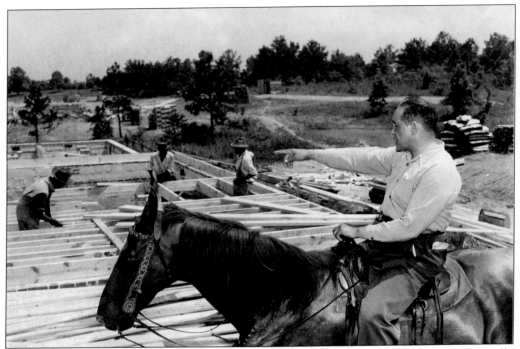

Blacks were a rising segment of Atlanta's population, and many settled into traditionally segregated neighborhoods west of town. During World War II, homebuilder and ex-football coach Walter "Chief" Aiken built over 100 homes in the Fairview Terrace neighborhood for African-American civilians working in war production facilities. Between 1943 and 1950, Aiken built over 3,000 new homes for African-American veterans in response to critical housing needs.

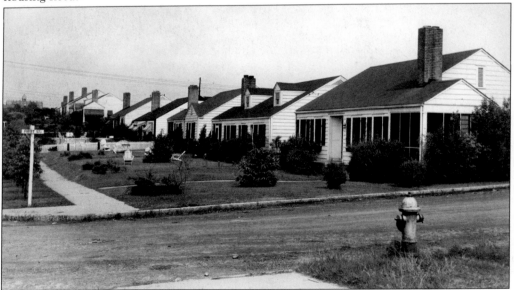

The above homes are in the Fairview Terrace neighborhood in Atlanta's west side. A building on the campus of Atlanta University is barely visible in the distance on the left.

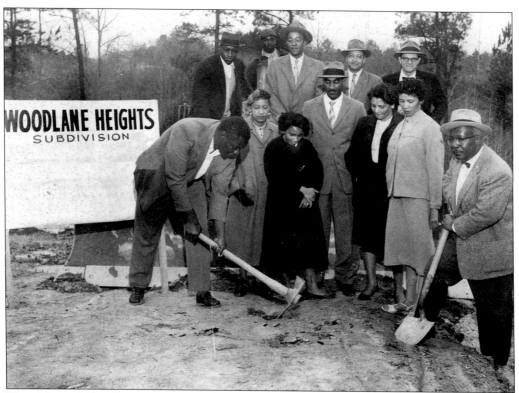

The Atlanta Urban League sponsored cooperative efforts between black leaders and real estate developers to develop low-cost housing for African Americans. (Atlanta Urban League Collection, Atlanta University Center, Robert W. Woodruff Library.)

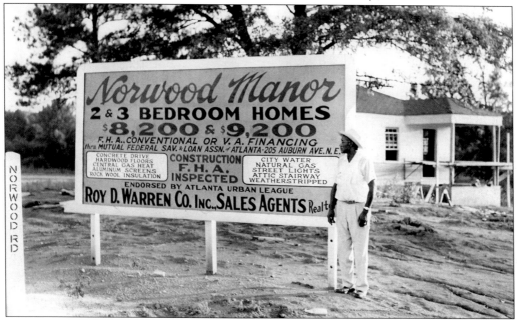

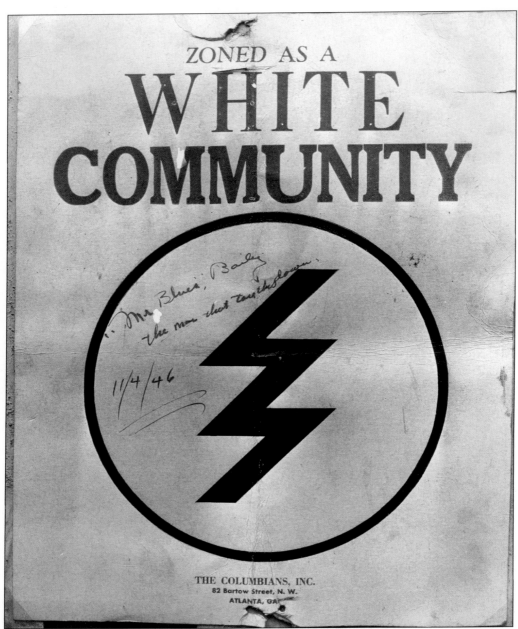

ZONED AS A
WHITE
COMMUNITY

"Mr. Blues", Bailey
the man that tore the down.

11/4/46

THE COLUMBIANS, INC.
82 Bartow Street, N. W.
ATLANTA, GA.

While African Americans peacefully settled into newly built neighborhoods, the integration of blacks into traditionally white areas met with resistance. In 1946, a terrorist group emerged in Atlanta known as the Columbians, a neo-Nazi unit that preached hatred of Jews, Communists, and the American upper-class. Its main targets, however, were African Americans who moved into established white neighborhoods. Posters such as these were used to intimidate black families who moved into homes formerly owned by whites. The group's vigilante tactics also included bombings and random assaults. Civic groups, including World War II servicemen from the Atlanta Veterans Committee, fought back, denouncing the "Hitler-born" organization.

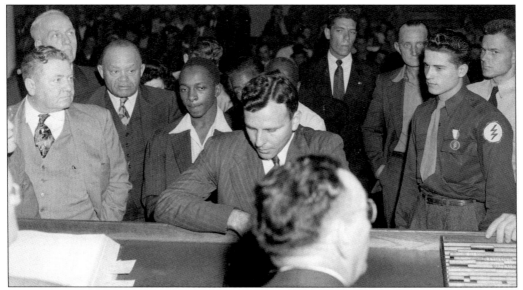

James Childers (right, with insignia), a 17-year-old member of the Columbians, is arraigned for his part in assaulting Clifford Hines, an African American. Although Hines (in white lapels, standing next to civil rights lawyer A.T. Walden) suffered an unprovoked attack by three men, he, too, was arrested and appeared at the arraignment with his attacker. Homer Loomis Jr. (far right), the organizer of the violent organization, glares at the photographer during the proceedings.

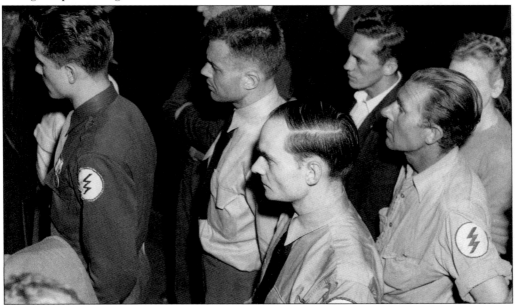

The parallels between the Columbians and Hitler's SS Elite Guard were obvious to most observers. Even the organization's insignia were incendiary reminders of the terror tactics of Nazi Germany's SS troops. State prosecutors eventually prosecuted many in the organization, including founder Loomis (upper center) and President Emory Burke on charges ranging from inciting a riot to usurping police authority. In the end, the organization had a short existence.

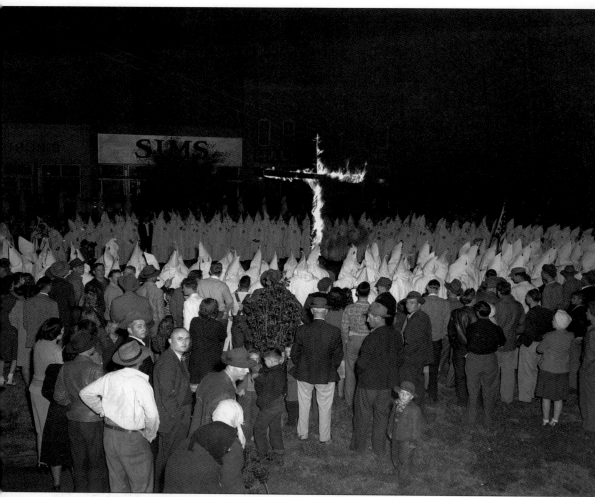

The Ku Klux Klan spread terror with a renewed vitality in Atlanta and throughout the South. An epidemic of racial killings and Klan violence marked the post-war years, spurred by fears that returning black veterans could become a revolutionary force.

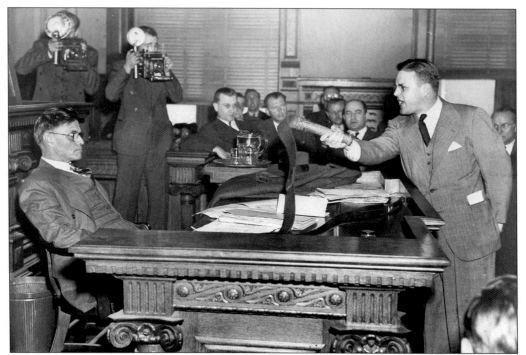

Assistant Attorney General Daniel Duke confronts former Georgia governor Eugene Talmadge with a leather whip that Klansmen used to flog their victims. Talmadge was testifying at a clemency hearing in support of the imprisoned Klansmen. Duke served under Gov. Ellis Arnall, who launched an aggressive campaign against the Klan.

In the 1946 gubernatorial race, Ellis Arnall, unable to run for reelection due to the state constitution, supported the moderate James V. Carmichael, who lost to Eugene Talmadge. Talmadge's sudden death after his election sent the electoral process into a tailspin. Talmadge's supporters in the legislature selected his son, Herman, as governor. After the vote, Herman broke into Arnall's office, changed the door locks, and seized Georgia's highest office.

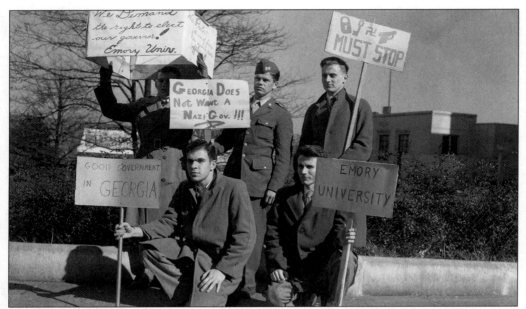

Students from Emory University, many of them veterans, protest Herman Talmadge's seizure of power during the infamous "Three Governors" controversy. Talmadge served as governor for 67 days until the Georgia Supreme Court ruled that the legislature exceeded its authority by electing him. Melvin Thompson, who won the election for lieutenant governor, was installed as acting governor until a special election could be held in 1948.

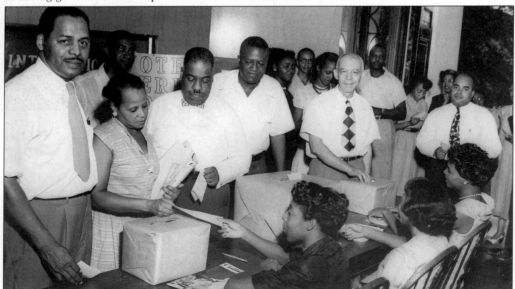

Atlanta University history professor Clarence Bacote (far left) oversees voting activity at an on-campus voting site. After the war, he was elected chairman of the Atlanta All-Citizens Registration Committee and successfully led the group's effort to register African Americans to vote. In less than two months, the number of black registered voters in Fulton County swelled from 6,000 to 21,000 in 1946. (Clarence A. Bacote Papers, Atlanta University Center, Robert W. Woodruff Library.)

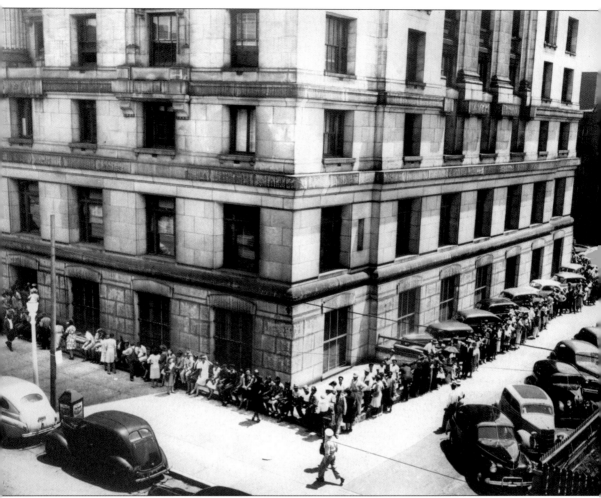

Black voters line the streets outside the Fulton County Courthouse. New realities were shaping the postwar South. A surging activism among African Americans helped bring about the fall of such traditional voting barriers as the poll tax and the white primary. Also, the war against fascism highlighted the contradictions of maintaining a racial caste system in a nation that espoused the promise of democracy and freedom. In 1946, the Atlanta chapter of the NAACP and the Atlanta Urban League formed the All Citizens Registration Committee. The committee, led by black leaders from churches, universities, and businesses, waged a successful campaign to register thousands of new voters in Fulton County.

See and Hear
CANDIDATES
IN THE MAY 13th PRIMARY

Mon., May 4 — Zion Hill Baptist Church, Rev. L. M. Terrill, Pastor

Tues., May 5 — Turner High School, Anderson Park

Wed., May 6 — Thomas H. Slater School, Sponsored by PTA

Thurs., May 7 — Allen Temple AME Church, Rev. R. H. Porter, Pastor

Fri., May 8 — St. Mark AME Church, Rev. D. T. Babcock, Pastor

Mon., May 11 — Mt. Moriah Baptist Church, Rev. R. Julian Smith,
Pastor

Tues., May 12 — Wheat Street Baptist Church, Rev. Wm. H. Borders,
Pastor

8:00 P. M. Each Night

Sponsored By

ATLANTA NEGRO VOTERS LEAGUE
In Cooperation With

West Side Voters League, Dixie Hills Civic and Political League, Summerhill Civic League, South Atlanta Civic League, McDaniel Street Area Civic Club, Thomasville Civic Improvement League and Western Heights Civic and Political League.

Established as a political force in the city, African Americans organized the Atlanta Negro Voters League in 1949. Black Republicans and Democrats joined the organization to present a united front in local elections. The league often sponsored forums in which mayoral candidates made direct appeals to the black community through personal appearances. (Atlanta Negro Voters League Vertical File, Atlanta University Center, Robert W. Woodruff Library.)

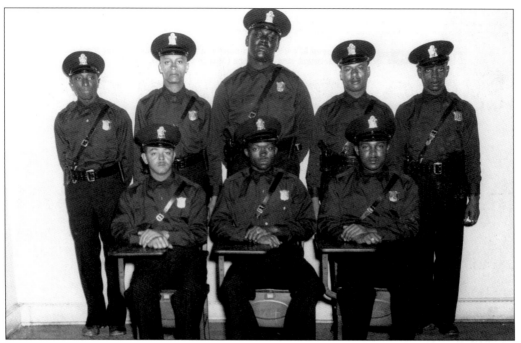

Despite the reality of segregation, increases in political power led to better city services for African Americans. One of the benefits was the hiring of Atlanta's first eight black police officers in 1948.

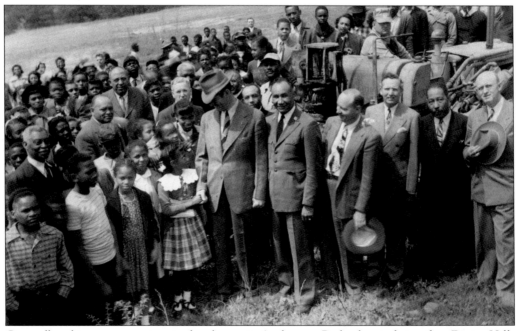

Groundbreaking ceremonies took place at Anderson Park, located in the Dixie Hills neighborhood in west Atlanta. The 80-acre playground was one of only three city parks open to African Americans by 1950.

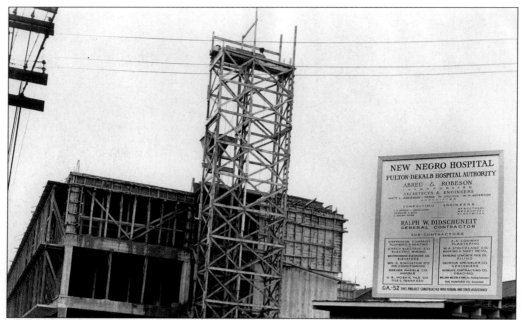

The Atlanta Urban League was successful in bringing the issue of hospital space for African Americans to the attention of city officials in 1947. That investigation led to the opening of the Hughes Spalding Pavilion of Grady Hospital in 1952. Named after the white chairman of the hospital authority's board of trustees, the facility remained segregated until 1964. (Atlanta Urban League Papers, Atlanta University Center, Robert W. Woodruff Library.)

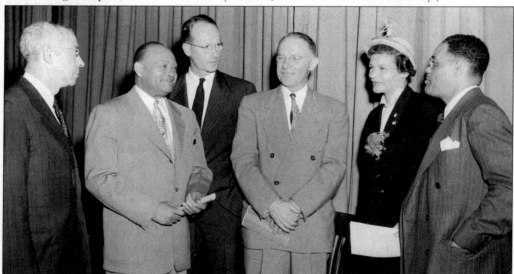

Strong civic leaders shaped postwar Atlanta. Between 1937 and 1961, William Hartsfield (third from right) presided over Atlanta's movement away from its Old South traditions to a spirit of cooperation in racial matters. He was helped considerably by such Civil Rights pioneers as (left to right) businessman Forest Whittaker, A.T. Walden, Phillip Hammer, Atlanta Urban League director Grace Hamilton, and Atlanta University Pres. Rufus E. Clement. (Atlanta Urban League Papers, Atlanta University Center, Robert W. Woodruff Library.)

Free from significant competition from other media, newspapers in the South once enjoyed an influence far beyond their circulation. Editors and writers like Ralph McGill of the *Atlanta Constitution* were widely recognized and dominated the editorial pages. A native Southerner, McGill was slow to support civil rights and was often hostile to groups like the NAACP. However, as the issue of racial discrimination came to the forefront after the war, McGill, unlike many of his peers in the southern press, came to understand the vital importance of this issue in the region. His blistering columns against bigotry and the Ku Klux Klan and his moderate tone on civil rights was credited for laying the foundation for better understanding between blacks and whites.

ACKNOWLEDGMENTS

There are a number of people who deserve special thanks and recognition for the assistance they provided in producing *World War II in Atlanta*. From the staff of the Kenan Research Center I would like to thank Micki Waldrop and Staci Catron-Sullivan for their help with research and captions; Glen Kyle, curator of military history, for his World War II expertise; Michael Rose, director of the Kenan Research Center, for his support and advice; Kenan Research Center volunteer and World War II veteran Chuck Raper for his special insight and valuable critique; and Karen Leathem, managing editor, for all her time and help in putting this book together. I would also like to thank Karen Jefferson and Cathy Mundale of the Atlanta University Center, Robert W. Woodruff Library, and Peter Roberts of Georgia State University for their help in selecting photographs from the collections at those institutions.

Paul Crater
Archivist, Visual Culture Collection
Atlanta History Center

RESOURCES

Ambrose, Andy and Darlene R. Roth. *Metropolitan Frontiers: A Short History of Atlanta.* Atlanta: Longstreet Press, 1996.

Bayor, Ronald H. *Race and the Shaping of Twentieth-Century Atlanta.* Chapel Hill: University of North Carolina Press, 1996.

Egerton, John. *Speak Now Against the Day: The Generation Before the Civil Rights Movement in the South.* Chapel Hill: University of North Carolina Press, 1994.

Ferguson, Karen. *Black Politics in New Deal Atlanta.* Chapel Hill: University of North Carolina Press, 2002

Fleming, Douglas L. *Atlanta, the Depression, and the New Deal.* Emory University, 1984.

Kuhn, Cliff and Harlon E. Joye , and E. Bernard West. *Living Atlanta: An Oral History of the City, 1914–1948.* Athens: University of Georgia Press, 1990.

Martin, Harold H. *Atlanta and Environs: A Chronicle of Its People and Events, Volume III. Years of Change and Challenge, 1940–1976.* Athens: University of Georgia Press, 1987.

Smith, Douglas S. *The New Deal in the Urban South.* Baton Rouge: Louisiana State University Press, 1968